COUNTRY
ARTS
IN
EARLY
AMERICAN
HOMES

COUNTRY
ARTS
IN EARLY
AMERICAN
HOMES

NINA FLETCHER LITTLE

Foreword by Wendell Garrett, Sotheby's

S·P·N·E·A
PUBLISHED BY THE SOCIETY FOR THE
PRESERVATION OF NEW ENGLAND ANTIQUITIES

DISTRIBUTED BY UNIVERSITY PRESS OF NEW ENGLAND
HANOVER AND LONDON

Society for the Preservation of New England Antiquities
Distributed by University Press of New England, Hanover, NH 03755

First published in both hardcover and paper in 1975 by E. P. Dutton & Co., Inc., New York, and in Canada by Clarke, Irwin & Company Limited, Toronto and Vancouver. Society for the Preservation of New England Antiquities paperback, 1999. Printed in the United States of America

ISBN 1-58465-025-7

Library of Congress Catalog Card Number: 99-71082

Designed by The Etheredges
Cover and title page designed by DeFrancis Carbone

Front cover: Upstairs guest room at Cogswell's Grant.
Back cover: Downstairs guest room at Cogswell's Grant.
Cogswell's Grant, c. 1730, in Essex, Massachusetts, the former summer home of Bertram K. and Nina Fletcher Little, is now a museum owned and operated by the Society for the Preservation of New England Antiquities.

FOREWORD

No one loved American folk art and America's folk artists with more ardent fervor or unpretentious ingenuity and clarity than Nina Fletcher Little; few have served them better. Because of her modesty, a stranger encountering her for the first time in a crowded room would not immediately have suspected the remarkable and imaginative delicacy of her thoughts and the subtlety of her perceptions. In her presence you became aware that grace of person was superseded by extraordinary agility and accuracy of mind and by warmth of heart. She grasped matters of importance with skill and rapidity and instinct. She was truly a pioneer in the sources she consulted and the subjects she opened up for research—subjects that have produced some of the most exciting and rewarding work of the last half of the twentieth century. She was a born collector who had the added gift of being able to blend possessions into a harmonious and

unobtrusive whole. Under her roof one had primarily the feeling of warmth and hospitable friendship to such an extent that only incidentally was one aware of the extraordinary beauty and quality of the individual objects that contributed to the surroundings.

In her research Mrs. Little went beyond the standard compendiums of published colonial newspaper advertisements of artists and craftsmen and searched the files of small-town little-known newspapers often found in local historical societies. She read extensively in the published eighteenth-century travel accounts of foreign visitors and delved deeply into architectural pattern books and self-help periodicals; she used as well manuscript account books, diaries, family and business papers, probate court records and vital statistics, town histories, family genealogies, state and local historical society proceedings, and even tombstones for vital dates of birth and death. Nina Fletcher Little was also a leader in seeking out the prints used as sources by folk artists and in mining academic paintings for evidence of how rooms were furnished and decorated. These sources, obvious today, had yet to be discovered by academic social historians of her time for what they would reveal about the lives of the unlettered, the inarticulate, and the little-known folk of history. Mrs. Little began writing and publishing articles and books on Americana in 1931; between 1938 and 1993 she published nearly fifty articles alone in *The Magazine Antiques;* the sum total of her articles, book reviews, and books (including this one originally published in 1975) by my counting, is 148. Her prose is clear, direct, and concise—an easy expository style unencumbered by florid modifiers and involuted construction. Informed and informing, her writing illuminates the lives of anonymous artisans and little-known itinerant artists in early nineteenth-century America. Her extensive bibliography reads like Homer's catalogue of ships; no person, before or since, amateur or professional, has contributed as much solid documentary information on the lives and works of these uncommon folk artists, who recorded the aspirations of the common people of America in an expansive new nation. Her energy was boundless; she approached serious antiquarian matters with eighteenth-century vigor and gusto.

During their long and illustrious lives, Nina Fletcher and Bertram

Kimball Little of Brookline, Massachusetts, assembled the most remarkable and distinguished collection of Americana in New England, if not the entire country. Their two houses—a country house, Cogswell's Grant in Essex, Massachusetts, where they spent the summer (now a historic house museum owned and operated by the Society for the Preservation of New England Antiquities) and a town house in Brookline, Massachusetts—were packed with antique objects of rarity and intrinsic interest that quietly looked well together and were used, with a freedom rare among American collectors, to make daily life more pleasant. The Littles began collecting soon after their marriage in 1925 and continued until their deaths in 1993, in their nineties, within four months of each other. Their passing marked the end of an era in the American antiquarian field.

"America is opportunity," said Ralph Waldo Emerson—and how many kinds of opportunity! "It is hard," wrote British diplomat James, Lord Bryce in 1905, "to resist the temptation to express one's admiration for the richness and variety of the forms in which civilization has developed itself in America, for the inexhaustible inventiveness and tireless energy of the people." The artifacts and paintings illustrated and discussed in Nina Fletcher Little's *Country Arts in Early American Homes* show that these plain people did seize their opportunities and display their tireless energy. In various ways the country arts offer a vision of the anonymous, unpropertied lives of silent men and women who lived, worked, and died without leaving a trace in the public record. Their historical legacy is their folk art, concerned with the aspects of daily life that mattered most to them and, by extension, to American society as a whole.

American folk art—unsophisticated in technique, pluralistic in expression, diverse in form, and uneven in quality—defies definition in the canons of conventional art history. Indeed, scholars even quarrel over the label "folk art"; it has been variously termed primitive, popular, nonacademic, naive, and vernacular art. Its practitioners have included professionals and amateurs, craftsmen and schoolgirls; their creations were commonly such utilitarian objects as tavern signs and weather vanes, although sometimes their product merely pleased the eye. Some artists (Edward Hicks for one) had a utopian vision, while others, mundane in their purposes and functional in their methods, sten-

ciled walls and grained furniture. These were the unselfconscious efforts of the
common people working under conditions that had never before existed. It is
the art of a sovereign, if uncultivated, folk living on an expanding frontier, cut
off from the ancient traditions or race, religion, and class. The American coun-
try arts illustrate something of the immense range, driving force, heterogene-
ity, and vitality of life on our continental stage.

Tolstoy understood how a nation or a people should be studied—not only
by observing the "masses" but also by finding the "infinitesimally small ele-
ments" that moved them. The bewilderingly diverse "country objects" produced
by America's folk artisans and artists are among these small elements, and by
focusing on them we can arrive at a better understanding of the changing well-
springs of invention tapped by American craftsmen and their burgeoning mid-
dle-class clients. Country art is aimed at the majority, and its standards are
determined by consensus. The country worker corroborates, often with great
skill, the values and attitudes already familiar to his audience. Predictability is
important to the effectiveness of folk art: it fulfills the expectations, provides
the pleasant shock of recognition, and verifies an experience already familiar.
Folk art assumes a massive audience, pluralistic in its manners, interests, tastes,
and economic and educational levels.

The rich diversity of the American mind, of which the country arts fea-
tured in Mrs. Little's book are one expression, can best be understood in the
context of our pluralistic society—a society of multiple allegiances, mixed loy-
alties, divergent ecomonies, different religions, and other interests. Unique in
the Western world, we are a nation born of revolt that was moderate, yet gen-
uinely revolutionary; a society that is liberal in its ideals, yet conservative in its
behavior, united in its divisions and divided in its unity. *E pluribus unum* was
not an idly chosen motto for the new republic.

WENDELL GARRETT

CONTENTS

COLOR
ILLUSTRATIONS

(FOLLOWING PAGE 174)

INTRODUCTORY NOTE

The term *country* in the title of this book is used in its broadest sense—not merely as a geographical description, but also as a characterization of a way of life that, in point of view, was essentially more rural than urban. Much has been researched and published concerning the homes and furnishings of wealthy citizens in large cities or prosperous towns. Less familiar, perhaps, are the personal possessions of the yeoman class, where these were kept, how they were used, and what variety of domestic goods was conveniently obtainable in rural America from 1750 to 1850. The illustrated sections that follow are designed to suggest some answers to these questions in the several fields of decorative arts that they explore.

The designation *country* was quite widely employed during the

eighteenth century. The needs of "country customers" and "country storekeepers" (referring to those outside the mainstream of urban economy) were much in the minds of metropolitan tradesmen and importers. The patronage of rural craftsmen and small shop owners was earnestly solicited in the local press, and ceramics, furniture, and wallpaper were among other items comprising "country orders" that were punctually supplied and expertly packed for transportation.

Social status, economic position, and availability of goods and services were all factors that determined standards of living wherever "home" might be. Thus low-income families everywhere depended to a great extent on home-produced products or reasonably priced imports, neither of which might have been acceptable to more affluent neighbors. Although middle-class taste generally reflected contemporary trends, it was usually an honest and unpretentious echo of high-style fashion.

Most of the items presented in the following pages originated along the Eastern Seaboard, many of them in New England, but other states eventually developed comparable indigenous arts and crafts. During the westward migration of the first half of the nineteenth century countless families moved themselves and their possessions to frontier settlements in New York, Ohio, Indiana, and Illinois. Other pioneers followed and traveled still further, toiling with a few cherished belongings across plains and mountains or rounding Cape Horn in sailing ships to settle on the West Coast. By the early twentieth century a significant number of family treasures once contained in simple, post-Revolutionary homes had accompanied their owners elsewhere. Many types illustrated here, and similar examples from other regions, may still be discovered, studied, and collected from Maine to California.

During the gathering of this material I have been indebted to many persons, some entirely unknown to me, whose research and writings have opened new fields of interest or focused my attention on fresh aspects of the American scene. Through the dealers who have shared their knowledge, and the numerous correspondents who have sent inquiries accompanied by photos, I have been led to unpublished historical and family data. Much of my earliest research on country arts first appeared in

articles undertaken for *The Magazine Antiques*. It seems particularly appropriate, therefore, that the Foreword should be contributed by the magazine's editor, Wendell Garrett, for whose scholarship in this field I am continuously grateful.

Requests for assistance from colleagues and friends have never gone unanswered and many have responded with information far beyond the call of duty. Among them are Sanger Atwill of the Lynn Historical Society; William P. Campbell, National Gallery of Art; C. R. Jones, New York State Historical Association; Barbara Luck, Abby Aldrich Rockefeller Folk Art Collection; Jane C. Nylander, Old Sturbridge Village; Huldah Smith Payson and John Wright, Essex Institute. To the institutions and individuals who have kindly allowed their pieces to be illustrated, and to the generous private collectors who requested that their names not appear, goes my warmest appreciation. (In all cases where a caption does not carry the owner's name it is understood that the object illustrated comes from a private collection.) Richard Merrill's excellent photographs, obtained through uncommon patience and skill, and my husband's invaluable assistance in editing and typing the final copy have both enriched the quality of the completed book. Finally, a very sincere thank you to Cyril I. Nelson who first suggested that I undertake this project and encouraged me to bring it to completion.

NINA FLETCHER LITTLE

COUNTRY
ARTS
IN
EARLY
AMERICAN
HOMES

ARCHITECTURAL DEVELOPMENT OF THE NEW ENGLAND COUNTRY HOUSE

The architectural background of the English settlers who came to America during the seventeenth and early eighteenth centuries inevitably influenced the first houses they built in the New World. Later, the demands of climate and a different way of life led to modifications in the old domestic patterns, and new trends in architecture slowly developed that finally became indigenous to the American Colonies.

Although many of the Pilgrims had lived in Holland before setting sail in 1620, it was not the Dutch but the English tradition that they perpetuated upon their arrival on New England soil. It has been estimated that fifty percent of the twenty-five thousand persons who had settled in New England by 1640 came initially from the three southeastern counties of Essex, Suffolk, and Hertfordshire. It was their building traditions together with those of Middlesex, Surrey, and Kent that

1

were perpetuated during the first fifty years of colonization of Massachusetts, Connecticut, and Rhode Island.[1]

Timber-framed structures were the architectural heritage of the English settlers, and log cabins were not a part of this tradition. The latter are believed to have been introduced to America by Swedish immigrants settling near the mouth of the Delaware River. They were also widely used for many years during the eighteenth century by German farmers from the Rhenish Palatinate.[2] When log construction appeared in seventeenth-century New England, it was intended primarily for defense, either in block or garrison houses.

Since this survey of architectural styles is necessarily limited, regional comparisons have not been undertaken. Instead, recognizable characteristics common to the majority of New England country houses are considered in chronological sequence from about 1650 to 1825; the purpose being to assist the interested amateur in determining with reasonable accuracy the periods of original construction and subsequent alterations. It should also be emphasized that dates cannot be arbitrary. Building practices varied in different localities, early methods lingered longer in some areas than in others, and each house was ultimately the expression of its individual owner's preference. Careful observation, however, of a large number of comparable examples does reveal a recognizable architectural similarity within a given span of years.

Fortunately many heavy-framed dwellings built well before 1700 still survive for study, although, naturally, all have been altered or enlarged to a greater or lesser degree. These houses were Elizabethan in character, with steep pitched roofs, small casement windows, sometimes framed or hewn overhangs, and large brick or stone chimney stacks. A one- or two-room unit, with chimney at one end or in the center, was the most common plan. This was followed by an addition across the back that was sheltered by a long lean-to roof and contained a new kitchen and fireplace, with a pantry and small bedroom at its ends.

Figure 1 shows the Richard Jackson house, long considered the oldest structure now standing in Portsmouth, New Hampshire, of which the earliest section, in the center, is dated 1664. Its appearance is typical

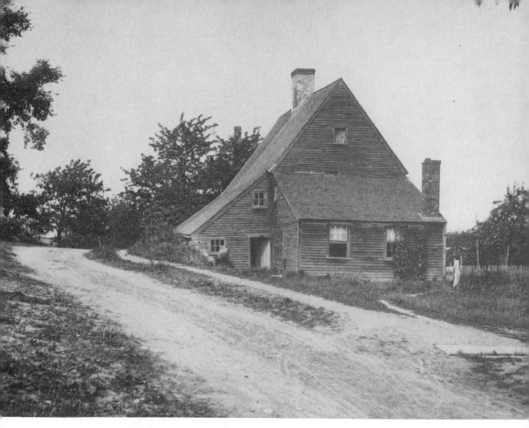

1. Richard Jackson house, Portsmouth, New Hampshire, 1664. Two additions were subsequently made to the original center section. (Society for the Preservation of New England Antiquities, Boston)

of the seventeenth century, with steep roof, added lean-to, large central chimney, and a second addition with its own chimney built at a later date. In figure 2 may be seen the Eleazer Arnold house in Lincoln, Rhode Island, dated circa 1686. This has two full stories and was built with a lean-to in the rear. The stone end and the pilastered stone chimney are features found in Rhode Island and Connecticut but seldom in Massachusetts, where brick was the traditional building material.

Houses of the first period were constructed with massive oak frames. This wood became so scarce in parts of Massachusetts by 1660 that "felling grants" were mandatory in Ipswich before cutting a single white

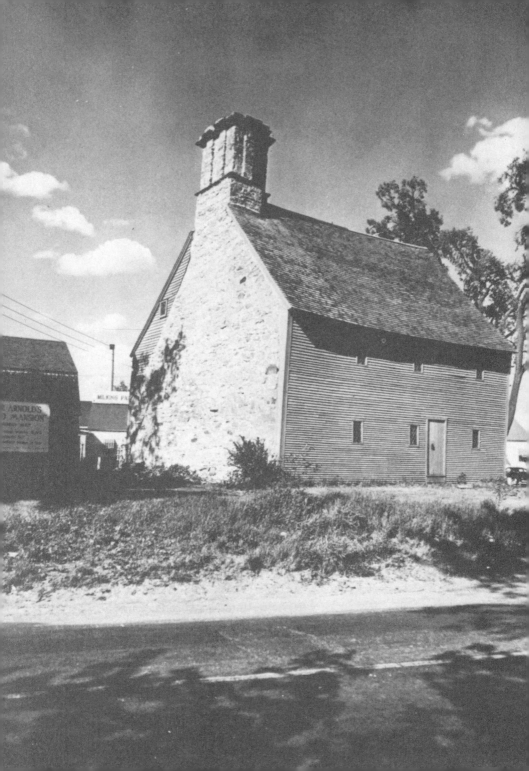

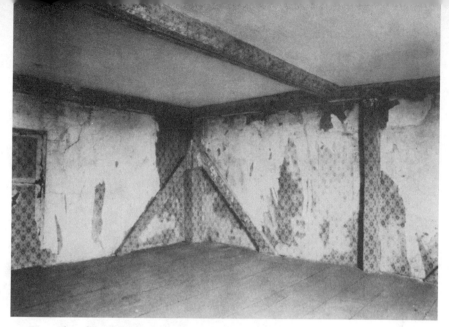

3. East chamber, Richard Jackson house, 1664. All the framing is visible in the room. (Society for the Preservation of New England Antiquities)

oak, and a penalty of ten shillings was imposed for every tree cut without permission.[3] All timbers except floor joists were hand-hewn and all remained clearly visible on the interior. Girts, posts, and corner braces were left exposed, and the sharp edges of summer beams, which spanned the ceilings and supported the joists, were given a decorative bead or "chamfer." The east chamber of the Jackson house provides an excellent example of a seventeenth-century room before restoration (fig. 3), every member of the frame being clearly apparent under the later-applied wallpaper. As time went on, beams such as these would be concealed behind plaster walls.

Sheathing usually covered the fireplace wall, the vertical unpainted boards having shadow or tongue-and-groove moldings that resulted in

2. Eleazer Arnold house, Lincoln, Rhode Island, c. 1686. The stone end incorporates several large fireplaces, and shows the roof line of the later wooden lean-to. (Society for the Preservation of New England Antiquities)

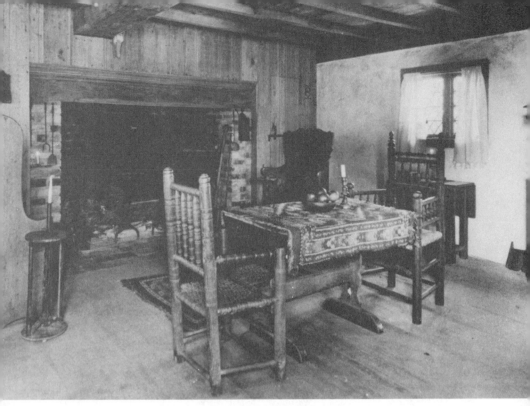

4. Room from the Matthew Perkins house, Ipswich, Massachusetts, 1685. The sheathed chimney breast and unplastered ceiling are seventeenth-century features. (The Concord Museum, Concord, Massachusetts)

decorative joints. Figure 4 illustrates a typical first-period room reconstructed at The Concord Museum. A sheathed chimney breast with whitened plaster on the outer walls, an open ceiling, and a small casement window are all elements common to the seventeenth century. A door beside the fireplace often led to the earliest type of enclosed winding stairs. Doors were constructed of wide boards held together on one side by stout battens, and latches were often made of wood rather than of iron. A good example of such a wooden latch may be seen on the right-hand door in the upper hall of the 1687 William Boardman house in Saugus, Massachusetts (fig. 5).

Undoubtedly, the great chimney stacks, with their mammoth cook-

ing fireplaces, formed the most dramatic feature of the seventeenth-century house. Stone or brickwork above the large rectangular openings was supported by a heavy timber known as a "lintel," and this was separated from the masonry on which it rested by two thin wooden blocks or "sleepers." Sleepers were intended to take up the normal con-

5. Second floor entry, William Boardman house, Saugus, Massachusetts, 1687. The batten door, early sponge painting, and large wooden latch are interesting survivals. The door at right leads to the attic. (Society for the Preservation of New England Antiquities)

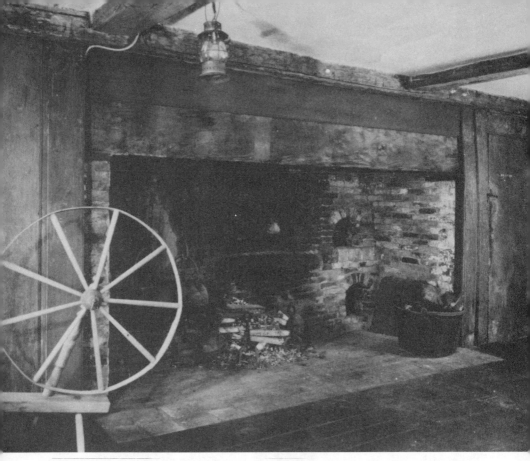

6. Kitchen fireplace, Swett-Ilsley house, Newbury, Massachusetts, 1670. The lintel beam rests on thin wooden "sleepers." An oven with ashpit below is built into the rear wall. (Society for the Preservation of New England Antiquities)

traction and expansion between the wooden lintel and the masonry on which it rested. A beehive oven was built into the back wall and occasionally, following English rural practice, the dome of the oven protruded on the exterior of the house if the fireplace was located in an end wall. The stone fireplace of the Arnold house once showed evidence of a former outside oven, and the remains of a projecting oven dome are still

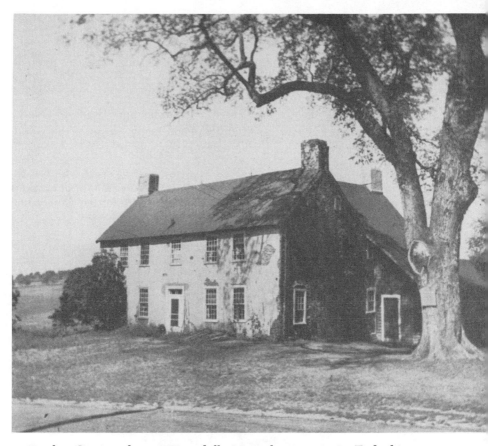

7. Peasley Garrison house, Haverhill, Massachusetts, 1710. End chimneys
and a less sharp roof pitch demonstrate its early eighteenth-century date.
(Photograph courtesy Society for the Preservation of New England Antiq-
uities)

visible at the rear of the Peasley Garrison house in Haverhill, Massachu-
setts. These early wall ovens had no separate flues; the escaping smoke
issued into the fireplace and was then carried up the chimney. A lug
pole made from a green sapling rested on transverse bars embedded
high up in the brickwork of the main flue, and it supported several
adjustable iron trammels from which hung various cooking pots below.

Figure 6 illustrates the kitchen fireplace in the 1670 addition to the Swett-Ilsley house in Newbury, Massachusetts, which measures ten feet, four inches wide, and exhibits all the elements typical of its period.

Even before 1700 significant architectural changes began to emerge that resulted in a gradual transition from the medievalism of the seven-

8. Lower hall, Peasley Garrison, 1710. The closed-string stairs with sheathing below, heavy turned balusters, and square newel post are typical elements of the earliest central halls. (Photograph courtesy Society for the Preservation of New England Antiquities)

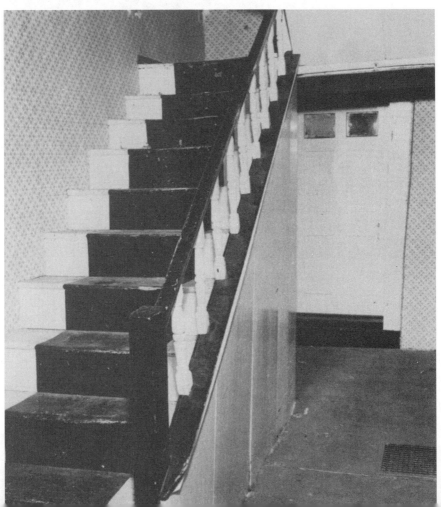

teenth century to the classicism of the fully developed Georgian style. Many houses newly built during the first half of the eighteenth century incorporated both traditional and innovative features, making this transitional period an especially interesting one. Roof lines became less steep, sliding sash rapidly replaced old-fashioned leaded casements, and the two-chimney, four-room plan with central hall made its appearance.

9. Kitchen, Peasley Garrison, 1710. The straight-sided fireplace, open ceiling, and enclosed winding stairs are earlier features often carried over into the transitional period. (Photograph courtesy Society for the Preservation of New England Antiquities)

10. Marshall house, Bucks County, Pennsylvania, first half of the eighteenth century. The original log construction may be seen at right, with doors and other wood trim added at a later date.

The Peasley Garrison built in 1710 illustrates a typical combination of transitional details (fig. 7). A new-style central hall with long staircase on a side wall shows an early eighteenth-century example of "closed-string" stairs, with short, heavy balusters placed at intervals having no relation to the position of the treads (fig. 8). In the kitchen

of the house the open ceiling, sheathed fireplace wall, and winding stairs look back to the seventeenth century (fig. 9). The Pennsylvania log house in figure 10 provides a welcome comparison of regional elements. The sheathing, cupboard with wooden latch, enclosed stairs, and batten doors are all reminiscent of an early style. The unusual folding doors that close over the large fireplace are characteristic of somewhat later Pennsylvania architecture and would not be found in a New England house (fig. 11).

During this period heavy framing was still much in evidence, although plaster now covered the joists, and wide boards encased summer

11. Fireplace, Marshall house. The convenient folding doors probably date to the late eighteenth century and are a distinctive feature of Pennsylvania architecture.

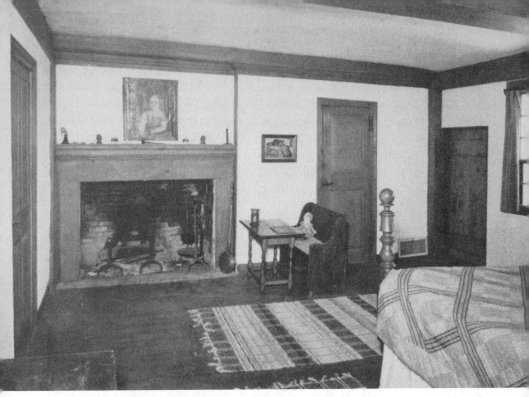

12. Kitchen chamber, Jonathan Cogswell house, Essex County, Massachusetts, c. 1735. Massive framing is still in evidence but is now accompanied by plaster on ceilings and walls.

beams and corner posts. Batten and two-panel doors were used side by side as seen in the kitchen chamber of the Jonathan Cogswell house, Essex County, Massachusetts, circa 1735, where other transitional features are found (fig. 12). Sheathing began to disappear before 1700 although it continued to be used for many years in back halls and attic stairways. The first addition made to the 1652 Tristram Coffin house in Newbury, Massachusetts, exhibits early paneling on a fireplace wall, together with one of the few remaining built-in dressers still in its original position (fig. 13). By 1725 cavernous rectangular fireplaces were almost a thing of the past although large openings fitted with lug poles and rear ovens

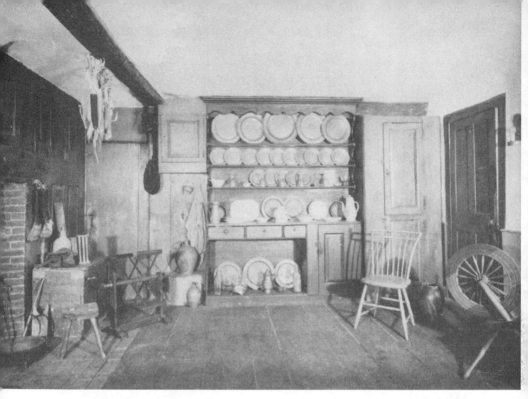

13. Built-in dresser, Tristram Coffin house, Newbury, Massachusetts. This room exhibits paneled woodwork and wall cupboards that updated the seventeenth-century interior during the second quarter of the eighteenth century. (Society for the Preservation of New England Antiquities)

were occasionally built as late as 1735 (fig. 14). It was becoming apparent, however, that smaller apertures with sloping walls reflected greater heat, and that side ovens and swinging cranes were equally efficient and more convenient for the housewife (fig. 15).

Well before 1750 the Georgian style, following English practice of the late seventeenth and early eighteenth centuries, brought an elaboration of detail heretofore unknown to the New England Colonies. Increased immigration of English-trained housewrights and importation of various builders' handbooks (such as those compiled by Batty Langley and Abraham Swan) aided in transmitting up-to-date information

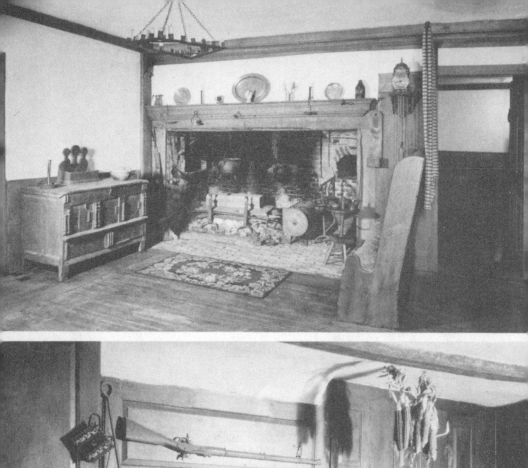

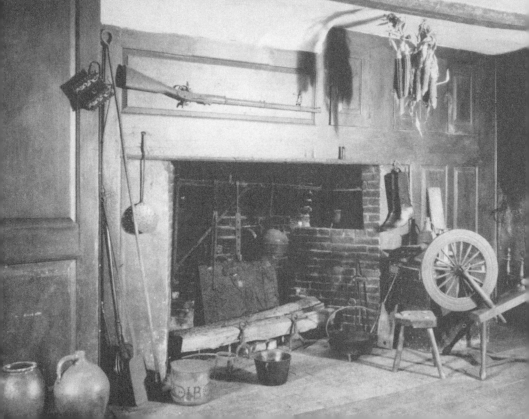

14. Kitchen, Jonathan Cogswell house, c. 1735. By this date a boldly molded mantel shelf covered the lintel beam beneath. Otherwise the fireplace retains its seventeenth-century appearance.

on current English taste. Although the handsomest woodwork was to be found in the homes of the wealthy, located in cities and prosperous seaports, Georgian elements were quickly adapted to farm homes in modest country towns.

Commodious two-story houses with hip or gambrel roofs joined the ranks of the always popular pitch-roof style. Many windows displayed twelve-over-twelve pane sash set in wide wooden "muntins," or glazing bars. Front doors assumed new and added importance. The 1732 gambrel-roof William Cogswell house, Essex, Massachusetts, demolished in the early twentieth century, illustrates the evolution from a seventeenth- to an eighteenth-century farmhouse (fig. 16). Its symmetrical fenestration, imposing pedimented doorway, and spacious two-chimney plan bespeak the emergence of a new stylistic trend. The lean-to, however, looks backward in form because its convenience was to perpetuate its use for many years to come. The Banister house in Brookfield, Massachusetts, built in the second half of the eighteenth century, provides a contrast in the country Georgian plan (fig. 17). It reveals a hip roof and foursquare facade with carved dentil cornice, and a transom-lighted door embellished with fluted side pilasters.

Inside these houses, and in others constructed between 1730 and 1780, there was much to please the eye. The most obvious innovation was raised-panel woodwork that covered the chimney breast and sometimes extended to other walls of the room. Two front rooms of the Jonathan Cogswell house are finished in early Georgian style. The best chamber contains a large fireplace with heavy bolection molding, while cedar-grained paneling heralds an increased interest in the use of in-

15. Kitchen, Tristram Coffin house, second quarter of the eighteenth century. This fireplace reflects the emergence of a new style. Size is reduced, walls are canted, an oven is at the side, and a crane replaces the earlier trammel hung from a lug pole. (Society for the Preservation of New England Antiquities)

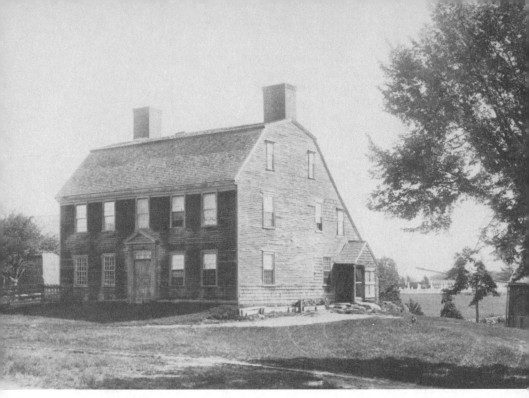

16. William Cogswell house, Essex, Massachusetts, 1732, now demolished. The ample proportions and pedimented door are early Georgian characteristics that appeared even in small country towns before the mid-eighteenth century.

terior paint (fig. 18). The massive timber frame is still apparent in this room, but it has been partially concealed by wide moldings and beaded casing boards.

A parlor wall of the Edward Devotion house, built circa 1744 in Brookline, Massachusetts, exhibits the surprising wealth of detail to be found in a small agricultural community during the mid-eighteenth century (fig. 19). Folding shutters, embrasured window seats, and crossetted fireplace moldings (distinguished by their jutting, triangular corners) all attest to rapidly changing taste. The corners of the upper and lower panels do not coincide, suggesting the hand of a country

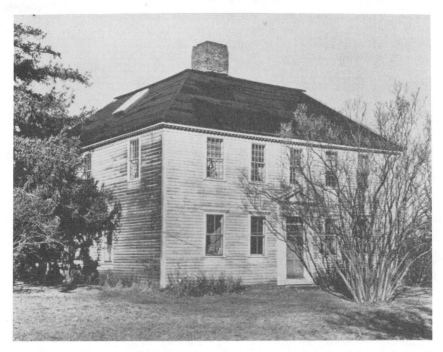

17. Banister house, Brookfield, Massachusetts, second half of the eighteenth century. This foursquare country mansion, at one time a tavern, occupies a commanding position on the Brimfield Road. A painting of the house itself once appeared as decoration on an overmantel panel therein.

builder. Two doors at the right, one with an arrangement of panels in the form of a cross, are fitted with a box lock and H and HL hinges. This hardware follows the architectural practice of the time. The HL hinge did not signify "Holy Lord," neither was a six-panel door ever known as a "Christian door." These picturesque terms are of distinctly modern origin.

In the Georgian period staircases became objects of special attention with treatment differing from house to house. The front entry of the Devotion house, although relatively small in area, contains a staircase of considerable elaboration (fig. 20). The stair-ends are exposed, with a

18. Hall chamber, Jonathan Cogswell house, c. 1735. Grain-painted woodwork in cedar and green characterizes the best chamber, finished in early Georgian style. The size of the ceiling beams is cleverly minimized by the application of decorative moldings.

19. Parlor, Edward Devotion house, Brookline, Massachusetts, c. 1744. This paneled fireplace wall illustrates the elaboration of mid-eighteenth-century carving. The back of the fireplace was later filled in to throw more heat into the room. (Brookline Historical Society)

20. Front entry, Edward Devotion house, c. 1744. Used for generations as a farmhouse, this small building contains unsuspected architectural riches. (Brookline Historical Society)

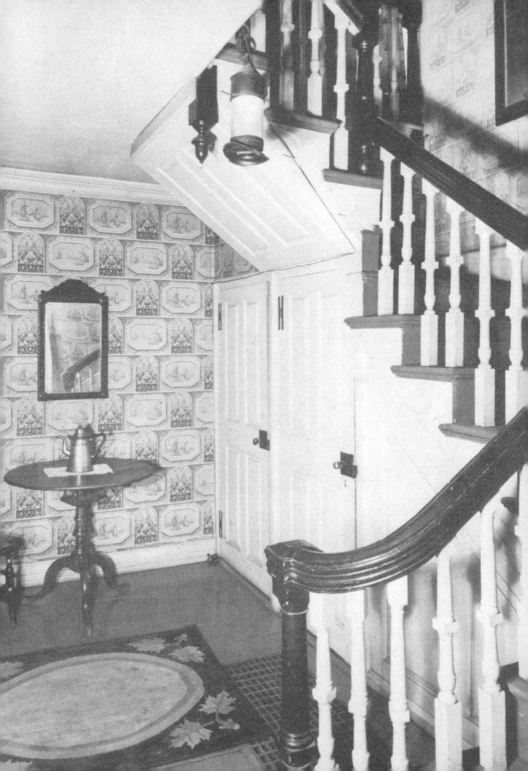

21. (RIGHT) Front hall, Jonathan Cogswell house, c. 1735. Two closed-string staircases, with slender, turned balusters and paneling below the main flight, exemplify Georgian features in a New England farmhouse of 1735.

22. (FAR RIGHT) Corner cupboard, Banister house. A good example of unsophisticated design: cupboards such as this served a primary function in storing china, glass, cutlery, and other household furnishings during the second half of the eighteenth century.

pair of balusters resting on each tread, and the handrail is nicely molded. Stairs of this period do not wind but ascend in three separate flights, having two square platforms that connect each straight run. A 1735 staircase, with well-turned balusters and paneling below (fig. 21), may be compared with the 1710 example previously shown in figure 8.

Corner cupboards were a specialty of Georgian interiors. High-style examples exhibited fluted pilasters and carved-shell tops, whereas country cupboards, such as that in the Banister house, had plain exteriors

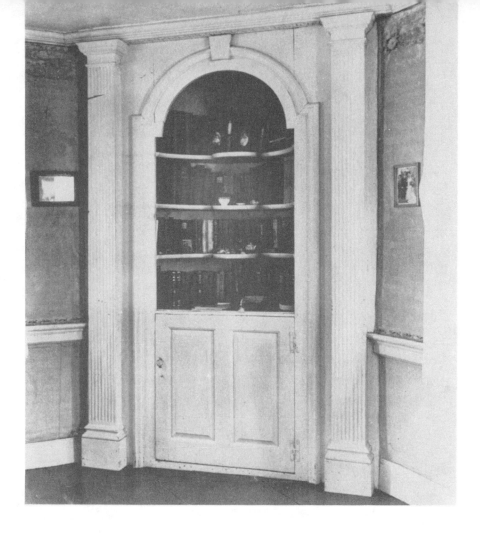

enhanced only by shaped shelves and a heavily molded enframement (fig. 22).

A utilitarian feature of this period was the smoke closet in which meat was hung to cure. These brick chambers were often built against a chimney in the attic and were connected at the back with a flue from the fireplace below (fig. 23). Many have been dismantled in recent years owing to possible fire hazards, but this example in the Banister house is unusually well preserved.

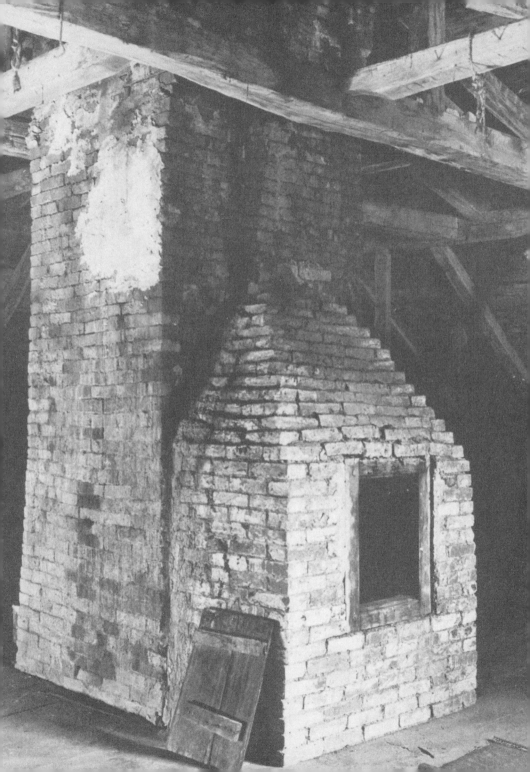

23. Smoke closet, Banister house. Brick chambers for smoking meat fulfilled a need on an eighteenth-century farm. They were built at various dates in several forms, and attached to chimneys in different parts of the house—in the cellar, attic, second-floor closet or ell.

Following the close of. the Revolutionary War another significant change became manifest in New England architecture. Known as the Federal or Neoclassic style, it lasted in country buildings from about 1785 to 1825. The influence of Robert Adam, Scottish architect and designer, was responsible for much of the delicate detail that appeared in turn-of-the-century American architecture and decorative arts.

Perhaps the most popular contribution of the Federal style to country exteriors was the two-story, hip-roof house, which had large windows, six-over-six sash, thin narrow muntins, and chimneys often incorporated in outside walls (fig. 24). Many of these comfortable, solidly

24. John Warren house, Brookline, Massachusetts, c. 1812. Farmhouses of this style, with fan-lighted doorways and square well-proportioned rooms, are still serving succeeding generations as attractive and functional homes.

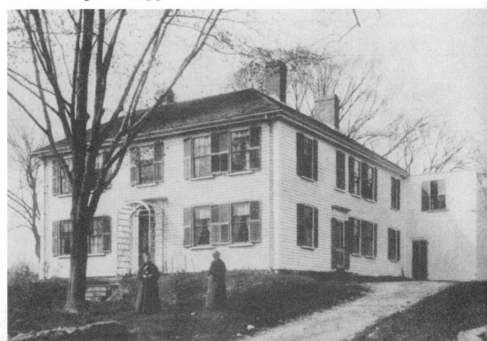

25. Parlor, John Warren house, c. 1812. Symmetry was admired in the Federal period, illustrated by this fireplace with matching doors at sides. Hand-wrought HL hinges disappeared and cast-iron butts took their place. Floorboards diminished in width and plain dados replaced paneled wainscot.

built homes appeared between 1790 and 1825 and are still very much in evidence throughout the New England countryside. Some were enriched by naïve versions of three-part Palladian windows, hallways lighted by overdoor fanlights, and facades enlivened by new-style slatted blinds.

Because many earlier houses were updated in the Federal period it is useful to observe changes of interior design that quickly outmoded the heavy Georgian style. By the end of the eighteenth century cased corner posts remained the only exposed elements of an otherwise concealed frame. Fireplaces became small and shallow, thus reflecting more heat into the room. Paneled chimney breasts disappeared, to be superseded by wooden mantel shelves having plain plaster walls above (fig.

25). In contrast to simple New England examples are those from central New York State where Greek Revival woodwork creates noteworthy elaboration (fig. 26). Ornamentation in Neoclassic interiors lacked the robust quality of Georgian carving, but became graceful, attenuated, and rich in detail. Swags, urns, and flower baskets of carved wood or plaster decorated mantels and overdoors; cornices were embellished with reed-and-rosette bands, and door panels sank below the stiles and rails (fig. 27). Spiral staircases with plain round balusters and mahogany handrails terminating in circular newel posts appeared simultaneously in farmhouse and mansion (fig. 28). Hardware underwent a noticeable change. Cast-iron butt hinges were imported soon after being patented in England in 1775, and rapidly displaced the former H and HL hinges.

26. Chimneypiece, Bowers house, Cooperstown, New York, first quarter of the nineteenth century. The elaborate pedimented mantel makes a significant comparison with the simplicity of New England fireplace treatment of this period. (Photograph courtesy New York State Historical Association, Cooperstown, New York)

27. Doorway of east parlor, Peirce-Nichols house, Salem, Massachusetts. Although the house was built by Jerathmeel Peirce c. 1782, the hall, east parlor, and parlor chamber were remodeled by Samuel McIntire in 1801. The doorway and surmounting plaster cornice exhibit one of the finest examples of Neoclassical design. (Essex Institute, Salem, Massachusetts)

Large box locks with brass knobs or factory-made latches also came into general use in the early years of the nineteenth century.

Before the advent of kitchen stoves about 1840, cooking arrangements finally evolved into the shallow fireplace with front oven (fig. 29). The Rumford Roaster—an early manifestation of the fireless cooker—was an ingenious development in fireplace design. This nineteenth-century innovation consisted of a three-foot iron compartment built within the front brickwork, from which two ventilators, connected with the chimney flue, regulated the amount of heat from the fireplace.

As time went on other architectural styles, each with its own characteristics, followed the Federal period. Before the middle of the nineteenth century, however, woodworking machinery began to supplant the

28. Staircase, John Warren house, c. 1812. A small front entry with bow-end accommodates this graceful flight. John Warren was a farmer and stonemason by trade, but the spiral staircase in his farmhouse was in the newest fashion.

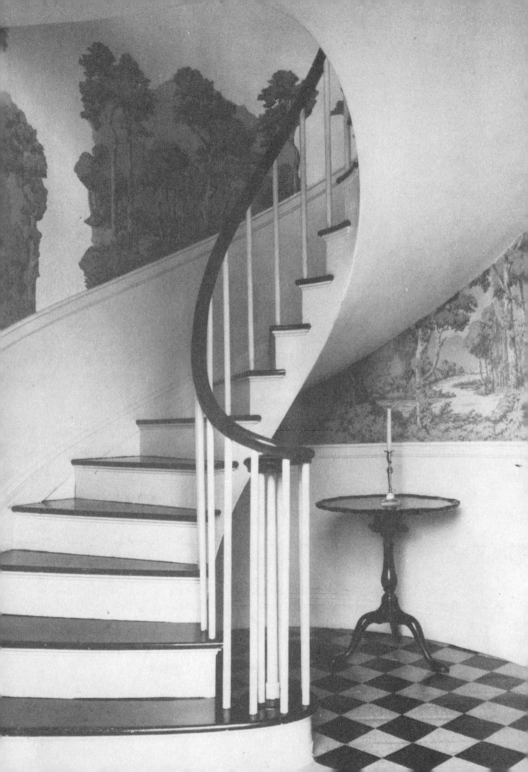

29. Luther Little house, Marshfield, Massachusetts, c. 1720. This early eighteenth-century fireplace was rebuilt around 1800 to provide modern cooking arrangements. The beehive oven, with its own flue, opens on the front wall—the most convenient development in early fireplace construction.

hand tools that had contributed to the distinguished character of New England country houses for over two hundred years.

NOTES

1. Martin S. Briggs, *The Homes of the Pilgrim Fathers in England and America* (New York: Oxford University Press, 1932).

2. Harold R. Shurtleff, *The Log Cabin Myth* (Cambridge: Harvard University Press, 1939).

3. Town Records, Ipswich, Massachusetts. Vol. 1 (unpublished).

THE FACE
OF
THE LAND

Through observation and study one may, in time, learn to recognize the salient features that characterized successive periods of American architecture. However, one can never quite visualize the old buildings as they actually appeared in their original surroundings. The early aspect of scattered villages and sparsely settled towns has disappeared, inevitably swept away by the exigencies of modern progress. The development of power machinery with attendant industrial towns; the coming of the railroads bringing an influx of commercial goods that eventually overwhelmed the old general store; the advent of the motorcar with its requirements of new and wider roads, these are just a few of the factors that gradually changed the face of the land and with it the quality of country life. Topographical views painted before the days of the ubiqui-

tous camera are now almost the only tangible reminders of many local scenes, and these pictures are in increasing demand as eye-witness documents of social and architectural history.

Landscape painting in a formal sense did not develop to the same extent as did portraiture during the eighteenth century. In fact, artists of the nineteenth-century Hudson River School are credited with having been the first to appreciate and transfer to canvas the sublime magnificence of the American wilderness. Although landscape views were painted on wooden chimney breasts in countless American homes during the second half of the eighteenth century, few overmantel panels depicted actual places—the majority being decorative compositions designed to fill a given architectural space.

It was often amateur artists working during the first half of the nineteenth century who really looked about them and tried to paint

30. Framingham Common, Massachusetts, as it looked in 1808. This New England town, like many others of its date, boasted a tavern, shoe shop, academy, meetinghouse, and green.

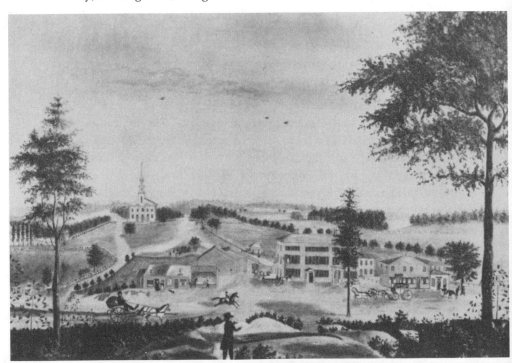

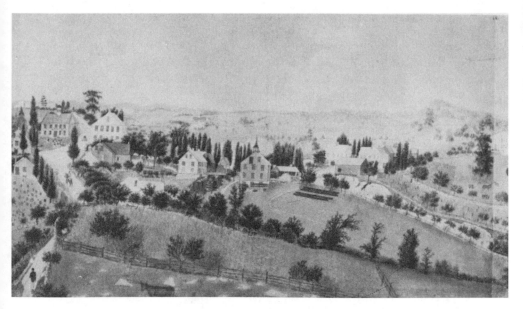

31. View of an unidentified village, c. 1830. This watercolor, found glued to the underside of a sewing table top, appears to be a young lady's version of a local scene. (Lyman Allyn Museum, New London, Connecticut)

what they saw. Some of their compositions were townscapes showing buildings of various ages and types. Other pictures portrayed churches, small mills, street scenes, or individual homes. The renditions vary from competent to naïve, but all record the visual aspects of places that have perforce changed greatly with the passing of time.

Figure 30 is an oil painting showing the center of Framingham, Massachusetts, as it appeared in 1808 when there were about sixteen hundred inhabitants scattered throughout the large township. The artist, Captain Daniel Bell, may be seen in the foreground surveying the main street of the town. In the doorway of the three-story tavern at the center stands the proprietor, Abner Wheeler, waiting to greet the passengers on the incoming stagecoach. To the left, across the road from the tavern, is the Larrabee shoe shop, and at the far left stands the old brick academy and gun shop almost hidden behind the ornamental trees,

planted at this time by vote of the town. Behind the tavern children play beside the red schoolhouse. The imposing white meetinghouse, raised in June 1807, dominates the green, with Reverend Kellogg's parsonage sheltered by woods across the fields.

Very similar in style and feeling is the village scene in figure 31, of which both artist and location are unfortunately unknown. The water-color was glued long ago to the underside of a sewing table top and appears to be an example of ladies' work. Houses and outbuildings are grouped in a traditional pattern—the rear of the church being visible in the center, and the academy with cupola and a group of scholars at the

32. *Eagle Mill*, attributed to Thomas Wilson, 1845, and the main street of Millville, New York. The building is identified as a gristmill by a sign lettered "FLOUR BY THE BARREL." A two-story tavern stands on the right beyond the bridge. An unusual stenciled frame is part of the canvas. (Abby Aldrich Rockefeller Folk Art Collection, Williamsburg, Virginia)

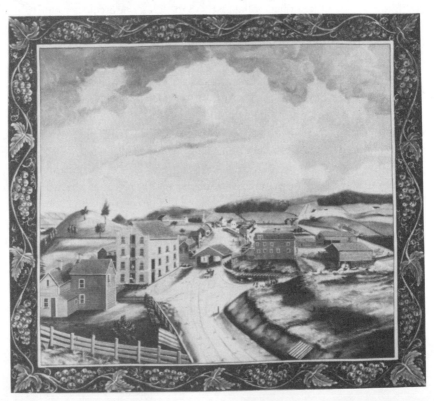

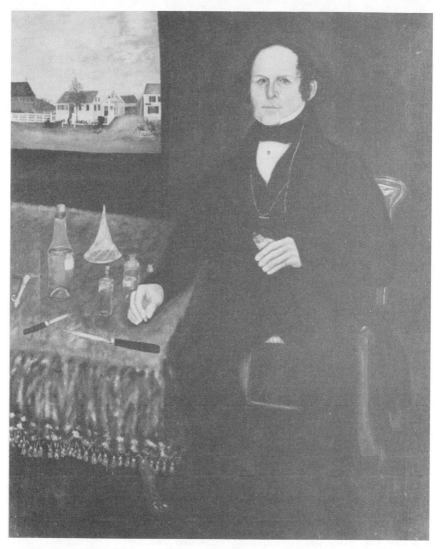

33. *Dr. Jesse Kittredge Smith* by Ezra Woolson, c. 1841. Dr. Smith's home and a typical doctor's gig are shown through a window at the left. (Old Sturbridge Village, Sturbridge, Massachusetts)

left on the hill. A documentary view of the Eagle Mill in Millville, New York, painted in 1845, includes every element of a small industrial settlement. The water-powered mill, covered bridge, tavern, and church may be seen in figure 32. In 1842 this town (four miles east of Troy) had one hundred and twenty-five inhabitants living in twenty houses,

and besides the gristmill had a sawmill, carriage manufactory, and general store.

Occasionally, an interesting glimpse of a village street appears in a so-called window view (fig. 33). Dr. Jesse Kittredge Smith was a typical country doctor who practiced for many years in Mount Vernon, New Hampshire, before his death in 1851. His portrait by the Fitzwilliam, New Hampshire, artist Ezra Woolson shows medical paraphernalia spread out on the table beside him, with his doctor's gig (presumably in front of his home) seen through a window in the background.

In 1813 Miss Susan Heath, age eighteen years, looked out from her father's home in the rural community of Brookline, Massachusetts, and painted the view from an east chamber window (fig. 34). Below her stretched the newly opened Worcester Turnpike, incorporated in 1806 to follow a straight westerly course from the brick schoolhouse in Roxbury to a point near the Worcester Court House. The hip-roof Georgian mansion still stands on the slope at left. Here lived Dr. Zabdiel Boylston, well known during the mid-eighteenth century for his introduction of inoculation for smallpox before the advent of vaccination. At the far right the white steeple of the second building of the First Parish in Brookline looms above the trees. This Federal meetinghouse has long since been replaced by a stone edifice erected on the same site. Particularly interesting is the distant view of the city of Boston featuring the State House and the open waters of the Back Bay, later filled in and developed with fine residences after the middle of the nineteenth century. In the distance at the right may be perceived a narrow road called the Neck that led to Roxbury. This causeway once provided the only overland route between Boston and the mainland until the opening in 1821 of the Mill Dam road, running from the foot of Beacon Hill to Kenmore Square. Susan's old home still stands virtually unchanged on Heath Street, but the meadows below it became a reservoir about 1850.

In the countryside that surrounded cities and large towns prosperous citizens often purchased extensive tracts of agricultural land and created gentlemen's country estates for profit and pleasure. Ezekiel

Hersey Derby, a prominent merchant of Salem, Massachusetts, acquired an old gambrel-roof farmhouse for this purpose in 1800. This he soon improved by commissioning the architect Samuel McIntire to enrich the parlor with carving and to design a classical garden house on an eminence across the way. At the same time he employed a locally esteemed artist, Michele Felice Cornè, to paint this view of his estate (plate 1). Situated on the road to Marblehead (now Lafayette Street), it was scarcely more than a mile from his Salem home. Derby cultivated the gardens and fields, and for many years drove out in style with family and friends to enjoy his country retreat. In the late 1860s, however, the acreage was divided and sold for house lots, and today the neighborhood retains no vestige of its once rural character. Another old-time scene in Southbridge, Massachusetts, appears in figure 35. Here farmhands neatly

34. *View of Boston* by Susan Heath, 1813. From her Brookline home, Susan could not see the "Old Elm" on the Common, but included it in her watercolor because she "knew it was there."

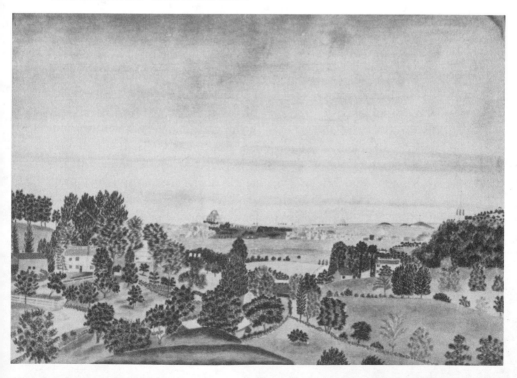

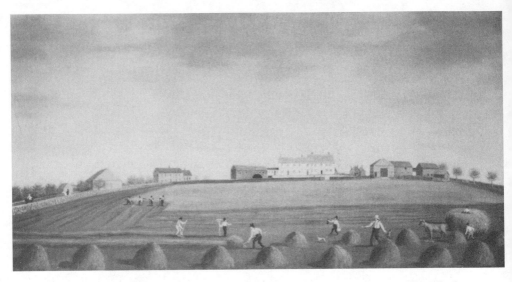

35. *Ralph Wheelock's Farm* by Francis Alexander, c. 1822. The Wheelock house, built in 1765, stood with the later ell on Denison Hill, Southbridge, Massachusetts. In the James Denison house at left lived his daughter, Experience, the first white child born in Sturbridge (now Southbridge). She later married Ralph Wheelock. (National Gallery of Art, Washington, D.C.; Gift of Edgar William and Bernice Chrysler Garbisch)

dressed, with suspenders and high-crowned hats, scythe, rake, and load an ox-drawn cart on Ralph Wheelock's farm before the days of modern agricultural machinery.

Townscapes were also painted in the early nineteenth century, but the carefully depicted buildings have now mostly disappeared. One young artist, Joshua Tucker by name, was born in Winchendon, Massachusetts, in 1800 and briefly attended the local academy in Hampton, New Hampshire. Although he trained to be a teacher, and became an expert in the art of penmanship, he soon abandoned pedagogy and after a time journeyed south. Entering the field of medicine, he began practice in South Carolina by traveling from place to place. While visiting the town of Greenville in the mountainous northwest corner of the state (once a popular summer resort, now a manufacturing city), he painted

this charming view in 1825 (fig. 36). Houses and public buildings in Greenville were then located on the main street, and the large edifice at the left is believed to represent the Mansion House, built in 1824, at one time a famous hostelry that survived until the 1920s. At the right was Greenville's most important architectural landmark—the Greek Revival Court House of 1823 where court was held until the early 1850s. Civil and political life centered about this building, and many prominent men addressed the citizens from its pillared balcony. It, too, stood until 1923. This picture is historically important because it shows the Court House as it was originally designed, before corner blocks and a cupola were added some fifty years later. Joshua Tucker subsequently spent four years in Cuba before returning to Boston where he eventually became a well-known dentist.

36. *Greenville, South Carolina* by Joshua Tucker, 1825. A watercolor by a young traveling doctor from New Hampshire depicting Greenville's main street before it became an industrial town. (Abby Aldrich Rockefeller Folk Art Collection)

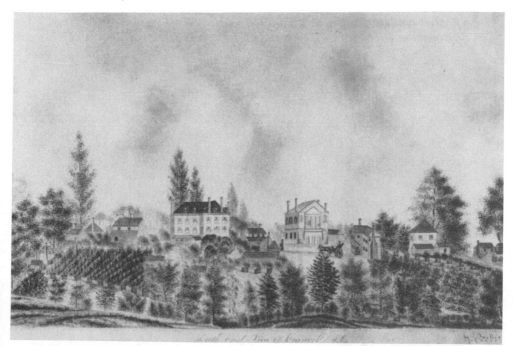

The thriving seaport town of Salem, Massachusetts, has long been famous for its fine Federal houses, many built by local merchants during the prosperous years following the War of 1812. Salem also had outstanding public buildings, among them Hamilton Hall designed by Samuel McIntire about 1805 and still used as an assembly hall. Several churches were designed or embellished by McIntire. The 1805 Custom House, Central Street, a pedimented brick block with columned doorway surmounted by a carved eagle, is also accepted as his work. Not least in architectural interest is the Market House in Derby Square, with fanlighted door and lunette window beneath a dentiled pediment. This building occupied a dominant position amid the stores of local produce dealers by which it was surrounded. Figure 37 shows Derby Square as it looked in the 1850s with the names of various fruit and vegetable merchants lettered on signboards above the doors of their shops. One of their number, Samuel Chamberlain of 22 Derby Square, here drives his stylish rig bearing the initials *SC* across the cobblestones. The old Market House, opened in 1816, and two large buildings in the left and right

37. *Market House, Salem, Massachusetts,* c. 1855. The names of several old produce firms appear above their stores in Derby Square.

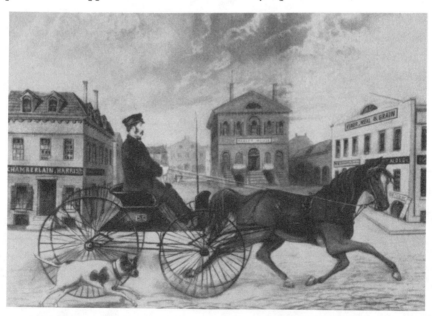

38. *Cambridgeport, Massachusetts,* c. 1825. This residential neighborhood has long since been engulfed by the city of Cambridge.

foreground, remain little altered today and it is hoped that urban renewal will spare this historic area.

A large tract of open land lying along the north bank of the Charles River has long since been swallowed up by the city of Cambridge, Massachusetts. This area was once known as Cambridgeport, where vessels docked to discharge cargoes before the open waters of Boston's Back Bay were filled in. Now that a network of city streets covers old Cambridgeport, it is pleasant to visualize one of its residential neighborhoods in the mid-1820s before the burning of the Hovey Tavern in 1828 (fig. 38). The tavern, with a high swinging signboard, appears at the immediate left and an interesting group of occupational buildings beside it. Included are a store, a soap factory, and hay scales with the handsome Livermore mansion just beyond. At the end of the street stands the

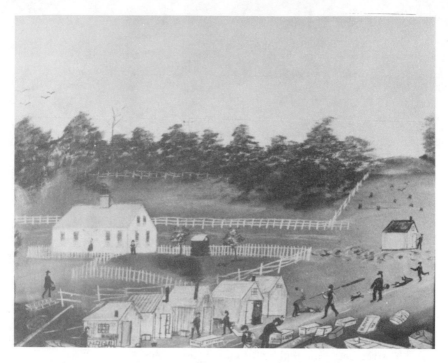

39. *Smelt Shacks, Bucksport, Maine,* by William P. Stubbs, c. 1858. A genre scene re-creating the traditional aspects of ice fishing and packing in a small Maine town.

First Universalist Church built in 1822 at the junction of Massachusetts Avenue and Main Street.

Quite a different type of local scene, painted in Maine in the 1850s, presents a row of smelt shacks that have been pulled up on the bank of the Penobscot River to await another season's fishing through the ice (fig. 39). In the background is the cottage of Abel Stubbs, who, with his wife in the doorway, stands beside their Bucksport home. When the Boston to Bangor boat sailed up river to Bucksport, it always sounded a whistle salute in honor of Abel's son, young Captain Stubbs. In the foreground men are observed packing crates of fish for shipment to Boston

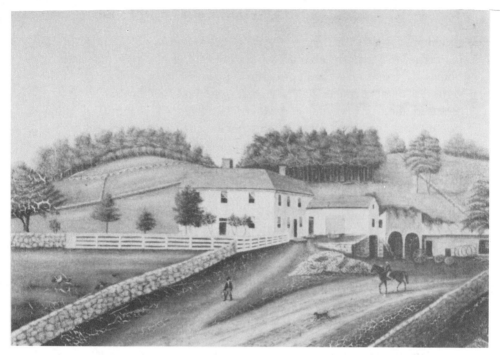

40. *Farmhouse in Charlton, Massachusetts,* early nineteenth century. Farms such as this, with its outbuildings and fenced fields, dotted the countryside before industrial development lured the young people away from the land. (Collection of Mr. and Mrs. Barnes Riznik)

and New York; the boxes bear the names of firms with which the local people traded. This naïve pastel was painted by "Billy" Stubbs while still a boy in Bucksport. Later, using his full name of William P. Stubbs, he was to become a marine artist working in Maine and Massachusetts during the last quarter of the nineteenth century.

Old pictures of individual houses painted in their original settings have much to offer in the way of documentary interest. A substantial farmhouse of the early nineteenth century in Charlton, Massachusetts, is shown in figure 40. It has a low hip roof with two central chimneys, and each small-paned window is hung with one looped curtain—a period

style now almost forgotten. At the rear stands a group of early outbuild-
ings of a kind that are now unfortunately falling into disrepair as farm
homes are modernized and agricultural pursuits become obsolete. At the
right is a small barn conveniently constructed on two levels with several
attached sheds for wagons and other useful gear. A practical combina-
tion of stone walls and wood fencing encloses the front yard and divides
the fields on the adjacent hills. A similar house belonging to Dr. Joel
Burnett in Southborough, Massachusetts, has four chimneys and red
brick end and appears to be slightly later in style (fig. 41). It probably
dates from about 1820 although the watercolor was not painted until
1843. Again the outbuildings catch one's eye—a shed door having long
strap hinges, and a barn with rows of holes for the convenient passage
of barn swallows. Rail and post fences enclose two informal gardens
comprised of low bushes and trees.

Constructed a generation later in Greek Revival style, the 1833

41. *Home of Dr. Joel Burnet, Southborough, Massachusetts, 1843.* Hip-roof
farmhouses of late Federal style, with square proportions, brick ends, and
plain interior trim, sprang up all over New England during the first quarter
of the nineteenth century.

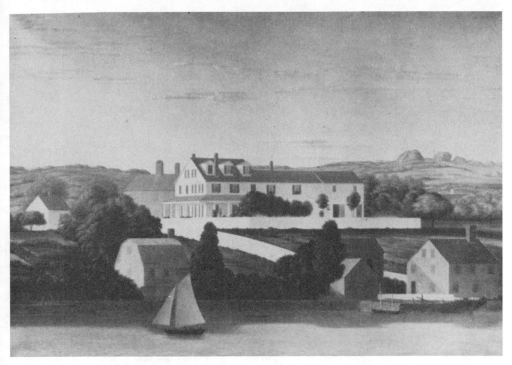

42. *Home of Captain Oliver Lane, Annisquam, Massachusetts,* by Alfred J. Wiggin, 1859. Built in 1833 this Greek Revival house, which still stands, then overlooked the wharf that served Captain Lane's clipper ships sailing in the China trade.

home of Captain Oliver Lane still stands as originally built looking over the Annisquam River (fig. 42). The small chimneys, columned porch, and interior arrangements of the square main house proclaim its affinity with the second quarter of the nineteenth century. Captain Lane sailed his clipper ships from Cape Ann, Massachusetts, to China, and so instead of barns he needed the wharf and countinghouse as they appear at the right below. Another merchant's home was owned by Joshua Winsor of Duxbury, Massachusetts (fig. 43). This country Georgian house, painted red with white trim and displaying an elaborately carved doorway, is shown on the waterfront where some of the family fleet of fishing vessels may be seen entering port. The tall figure at the right is Joshua himself,

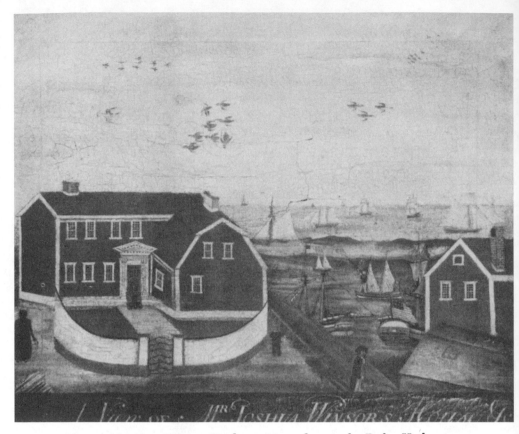

43. *Home of Joshua Winsor, Duxbury, Massachusetts,* by Rufus Hathaway, c. 1793. Few eighteenth-century merchants' houses were painted with this attention to detail. The artist, Duxbury's first physician, married Winsor's daughter. (New England Historic Genealogical Society, Boston)

keys in hand, walking toward his warehouse used for storing the salted fish that was cured on "fish flakes" nearby.

During the eighteenth and nineteenth centuries the all-important meetinghouse was often placed on a hill dominating the local scene. A fine example of this custom shows the handsome edifice in South Hadley, Massachusetts, raised as the second church building in 1761 and demolished in 1844 (fig. 44). At its right stands the foursquare Dwight homestead, moved in 1901 to a new location to make way for the Art

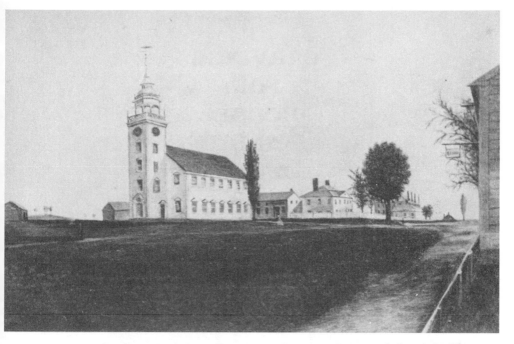

44. An early view of South Hadley, Massachusetts. The second church building was raised in 1761. Part of the site is now occupied by buildings of Mount Holyoke College. (Photograph courtesy Society for the Preservation of New England Antiquities)

Building of Mount Holyoke College. Behind the tree are glimpsed the four tall chimneys of the old College Seminary that burned in 1896. Beyond this at one time stood a hotel, a livery stable, and several small stores.

Nostalgic views such as those illustrated still preserve the atmosphere of a bygone day. But more than this, they have become historical documents depicting contemporary scenes that few can now remember and none will ever see again.

CARVINGS
FOR
HOUSE
AND
BARN

Before the middle of the nineteenth century the majority of small household articles were made by hand. Most of them were fashioned for utility, whereas only a few served as ornaments for mantelpiece or parlor table. Today one is amazed at the amount of carved embellishment on many of these simple objects, thereby lifting them from the purely functional into the realm of true craftsmanship, expressed in pleasing form and modest decoration.

Wooden utensils served the needs of almost all country families during the eighteenth and early nineteenth centuries, sometimes augmented by such items of pewter as the family felt able to afford. Pewter flat and hollow ware was necessarily provided by professional artisans, whereas woodenware was easily fashioned in the home.

Butter, as one of the staple products of every farm, was churned from the heavy cream that rose on fresh milk after it had stood for some hours in earthenware dishes on cool pantry shelves. One inventory of 1752 lists "40 milk pans and pots" in the buttery of a prosperous New England farm. Figure 45 was photographed some years ago in the Tristram Coffin house, Newbury, Massachusetts, and shows one of the few remaining dairy rooms that retained much of its original flavor. Here butter- and cheese-making implements include churns, a wooden firkin, and two typical red earthenware pans waiting to be filled with the morning's milk. After churning, a paddle was used to "work" the butter. This process involved turning and pressing to extract the residue of milk and ensure that the butter would keep well and remain sweet. Wooden stamps were used to imprint the tops of individual pats. Early examples were hand-carved with all manner of decorative devices, while later ones were factory-made. A nicely carved paddle for working butter, and three different types of stamps are shown on the shelves in figure 46. Included are a large, round print of familiar pattern at the right on the top shelf, a smaller example with a convenient handle is near the center, and a delicately swirled stamp fitted with a small ring on the reverse side, for easier manipulation, is at the left on the bottom shelf.

A sturdy lemon squeezer, worn smooth with use, appears in the center of the upper shelf with an old-fashioned masher at the left; it was needed for many kitchen purposes before the advent of the electric mixer. Not content with producing a useful kitchen utensil, the maker endowed it with particular merit by adding graduated bands of ornamental carving surmounted by a shaped handle with faceted knob. The food-chopping mortar at the left on the bottom shelf shows the special attention of its maker, who carved three serrated bands on it, prior to the application of a protective coat of ocher paint. At the extreme right is a small covered cup cut with geometric designs. Continental in form, it could have been brought back for use in an American home. In the center of the lower shelf appears a wooden scoop fashioned in the exact form of a large surf-clam shell. Beside it is seen a chamber candlestick, which was made and used on a New Jersey farm for generations, with a

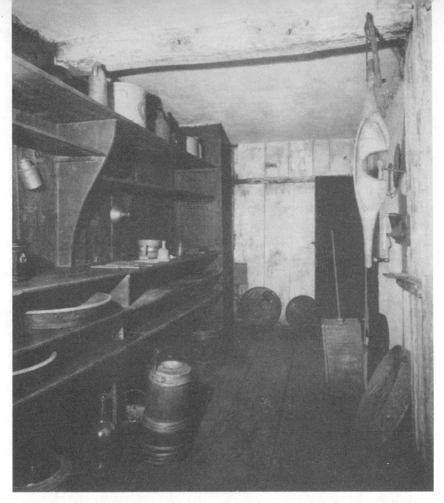

45. Buttery of the Tristram Coffin house, Newbury, Massachusetts, second quarter of the eighteenth century. Household utensils of various periods combine to create the atmosphere of an old-time milk room. (Society for the Preservation of New England Antiquities)

base and handle shaped from one piece of wood. Above is an expertly carved jagging wheel or pie crimper of a type that is also found in sailors' scrimshaw work. It is pleasant to realize that the extra time and effort once spent on such everyday objects both gratified man's urge and ability to whittle, between more active hours, and strengthened his re-

gard for the working contributions of wife and daughter to the life of the family.

Various kinds of receptacles were used to hold cutlery, of which hanging racks for spoons were perhaps the most diverse. On the left in figure 47 is an unpainted specimen that descended in one of the early families of Bergen County, New Jersey, and bears on the back the dates 1705 and 1757, suggesting possession by two successive generations. Its boldly conceived carving perpetuates the European tradition often seen in the work of men of Scandinavian or German descent. A striking comparison is apparent in the New England example on the right, appealing to the eye chiefly through the graceful curves of the backboard. Beneath the worn robin's-egg blue of the present surface are traces of an earlier coat of red paint. Some spoon racks were designed with a lower com-

46. Hand-carved woodenware on shelves of a pine kitchen dresser, first half of the nineteenth century. English pewter plates were often used on New England tables, and were listed by the pound in eighteenth-century inventories.

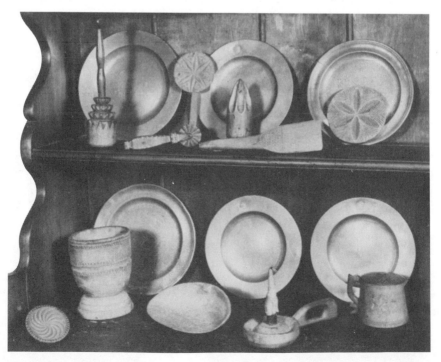

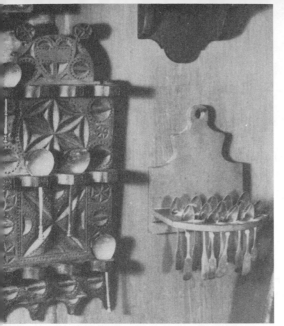

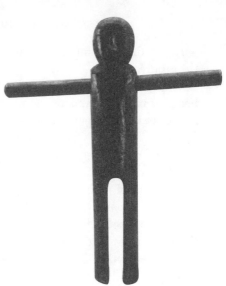

47. Spoon racks in two contrasting styles, early eighteenth and early nineteenth centuries. At left an elaborately carved New Jersey example with seventeenth-century English spoons. The New England rack at right holds thirteen American silver teaspoons.

48. Bed wrench in the form of a man, nineteenth century. Used to tighten bed ropes before the invention of metal bolts and springs. (Formerly in the collection of Old Sturbridge Village, present whereabouts unknown)

partment for storage of knives and forks, while two-part rectangular trays became popular during the mid-nineteenth century (fig. 122).

Wooden bed wrenches were a necessity in every home when ropes to support straw ticks or feather mattresses had to be pulled taut to keep bed frames together before the days of metal bolts. These objects were purely utilitarian and gradually disappeared after roping became obsolete. In one case an unknown householder shaped his wrench in the form of a man and so, unwittingly, ensured its permanent preservation as a cherished bit of indigenous folk sculpture (fig. 48).

Telling time at night became a real problem if a large clock was not within easy sight. Side tables were seldom at hand when bedsteads stood in rooms used for family living. Convenient ornamental boxes in

which to place a timepiece were hung on nearby walls, thereby protecting the watch from mishap and making the timepiece continuously available. Watch holders are found in many forms from carved and gilded eagles to fine examples in mahogany or satinwood. Two sturdy country pieces of painted pine are seen in the center of figure 49, that on the left with a crest and a heart suggests it was a gift to a lady. On the extreme right stands a nicely carved box with sliding front panel that reveals the space within. At the far left is a noteworthy specimen, beautifully fashioned of mahogany with ivory inlay, a perfect miniature of a grandfather clock. Here the watch fits into an aperture at the back of the "hood" instead of hanging from a hook inside.

One-of-a-kind items especially intended for sweethearts and wives naturally received additional attention. Among them were the small upright lap looms on which tapes for curtains, clothing, and other personal articles were woven. Fortunately these pieces often bore an

49. Watch holders to stand, or hang against a wall, early nineteenth century. The two at center retain their old red paint; the others are carved and finished in natural wood.

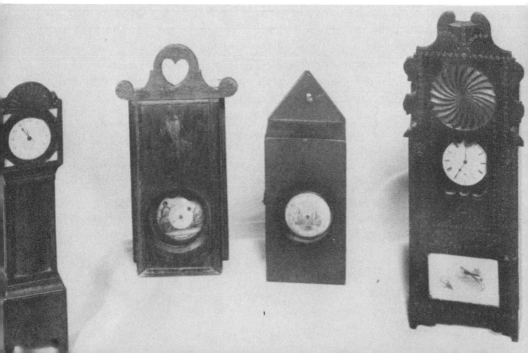

owner's name and a date, thus adding considerably to their present interest and value. The plain but sturdy example at the left of figure 50 bears the initials *HT* and the date *1734*. At the center is a pine loom from southern New Hampshire with carved and punched decoration, incised *Nane Robie*—phonetic spelling for Nanny. On the reverse is cut the name of the maker, *John Robie December 23 1767*. The early oak loom at the right, with rounded top and familiar chiseled star, carries the slyly humorous inscription, *Keep Me at Home,* and initials *CD* and *W, 1727*. The rare seventeenth-century tape loom illustrated in figure 51 is attributed to the Ipswich, Massachusetts, carver and joiner Thomas Dennis (c. 1638–1706), whose distinctive ornamentation appears on several pieces of oak furniture that have descended in the Dennis family. Among the inherited items is a tape loom with carving and design corresponding so closely to the example shown here that it corroborates the attribution to Dennis.[1]

Perhaps the most intimate items made for personal adornment were eighteenth-century busks that fitted into long narrow pockets sewed into the fronts of ladies' stays. Pockets opened at either top or bottom, and a

50. (FAR LEFT) Three early tape looms, inscribed with initials and dated (from left to right) 1734, 1767, and 1727. These looms were made as personal gifts to sweetheart or wife.

51. (LEFT) Oak tape loom from Essex County, Massachusetts. Attributed to Thomas Dennis, joiner, working in Ipswich in the late seventeenth century. The bottom block replaces part of the handle.

busk must have required an uncomfortably erect posture at all times. A corset, stiffened by means of closely stitched ribbing, is shown in figure 52 with one end of a busk projecting to indicate its position. Many busks of wood or whalebone were traditionally made by absent lovers on long and lonely voyages. One is carved with the message: *When this you se remember me 1760.* Another, in the center of figure 53, exhibits decoration of fairly good quality, although the maker had serious difficulty cutting the letters on the reverse. The result, however, attesting the romantic legend of an absent fisherman, reads: *July ye 17, 1764, A busk made at ye Grand Bank.* Sometimes pinwheels, swags, and graceful borders were beautifully carved with obvious taste and talent. In other instances the giver seems to have been more devoted than accomplished, but inexperience seldom deterred artistic effort. A sampling of typical eighteenth-century busks appears in figure 53. The second from the right has very fine chip carving and was made for Eunice Davis of North Weymouth, Massachusetts, in 1787. The most unusual design in the group is at the far right, with an intricately cut vine and a heart-shaped mirror inset at the top.

52. Corset with carved busk. A long pocket stitched to the underside of the garment held the busk in place.

Figure 54 illustrates an arrangement on a country dressing table that includes an American redware toilet set, pincushion box, wooden mirror, horn comb, and two milliner's figures used as stands for ladies' bonnets. The papier-mâché head at the left is a conventional shop window model of French design, but the characterful lady on the right is

53. Five eighteenth-century wooden busks, second half of the eighteenth century. Traditionally the work of sailors, they were also made of whalebone.

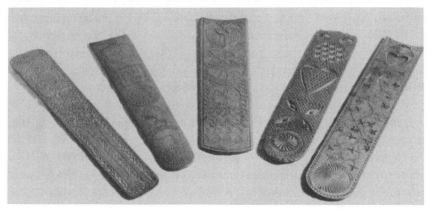

54. Country dressing table with nineteenth-century bonnet stands, redware toilet set, wooden mirror, and curved horn comb. The pincushion clamp at right end of table is dated 1776, a forerunner of the Victorian sewing bird.

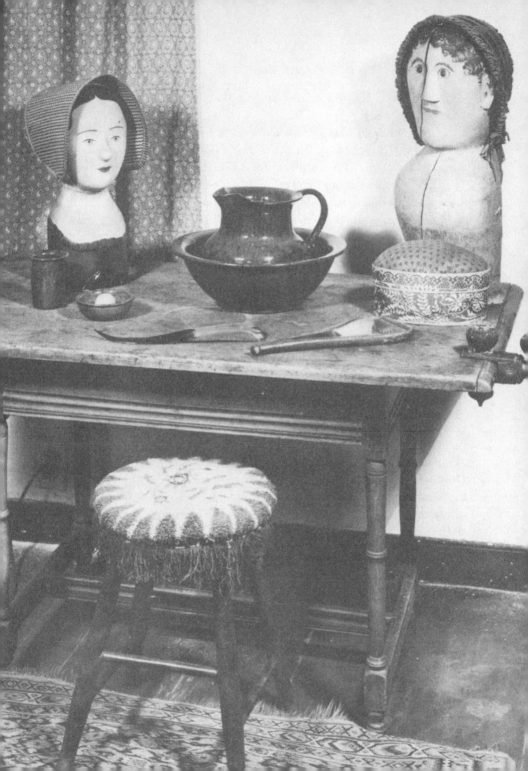

homemade, and the old cracks suggest that her age may well be over one hundred years.

Occasionally a naïve craftsman essayed formal sculpture, as in the piquant bust in figure 55. In other cases portrait medallions, skillfully executed in low relief, substituted for pictures on parlor walls (plate 2). The large plaque resting on the chest is attributed on stylistic evidence to Samuel McIntire, the Salem carver in whose inventory "8 medallions of Washington" valued at $2.00 each were listed in 1811.[2] Other carvings for homes included ornamental birds to stand upon the mantelshelf, carved coconut shells from the Tropics, and incised ostrich eggs, as souvenirs of foreign travel.

Apart from a few farm implements fashioned with pleasing lines and embellished with artistic skill, sculpture for the barn is exemplified by the handsome wooden weathervanes that were once a familiar country sight before their disappearance due to wind, weather, and other hazards. Many old metal vanes are still in place, but the majority of these were not made by hand. Cast in almost every conceivable form, they were factory products made after the Civil War when mass production quickly supplanted the individual craftsman. Copper vanes were advertised in well-illustrated catalogues, two of the best known having been issued by J. W. Fiske of New York City, and L. W. Cushing of Waltham, Massachusetts.[3] Many metal models paralleled wooden vanes. Only a few wooden examples of eighteenth-century date remain—most in use today originated well after 1800. Some vanes that perpetuate the old traditions were carved even as late as the opening years of the twentieth century.

Each handmade vane was a one-of-a-kind creation of its maker even though his personal identity may have been forgotten long since. The cockerel has always been associated with religious symbolism and appears on public buildings as one of the earliest weathervane forms in America. Notable among early metal cocks was one by Shem Drowne placed on the New Brick Church in Boston in 1721. After the building was torn down, the Shepard Congregational Society purchased it in 1873 for their new stone church in Cambridge. Another cock tops the

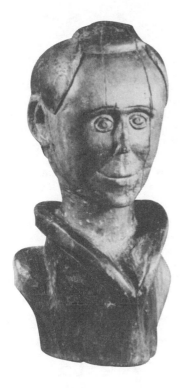

55. Bust of a man shaped from one piece of wood, c. 1825. Despite the maker's lack of skill, the features express both liveliness and humor.

steeple of the Congregational Meeting House in West Barnstable, Massachusetts, having been brought from England around 1723.[4]

A well-documented wooden cock is illustrated in figure 56 as it appeared when undergoing repairs some years ago. This fine bird was hand-carved for the spire of the old Cumberland County Court House built in 1786 in Portland, Maine. When the building was later used for other purposes and eventually sold, the gilded weathercock was preserved. In 1884 it was placed on the tower of the First National Bank Building in Portland, where it has since served its original purpose well. A second wooden cock of late eighteenth-century vintage (fig. 57) is said to have come from a long-vanished meetinghouse in the vicinity of Bethel, Maine.

In 1749 the little town of Hampstead, New Hampshire, was incorporated and the frame of its first small meetinghouse was raised. The

56. Cock weathervane, grounded for repairs. Carved in Portland, Maine, in 1788, it illustrates the traditional vigor of eighteenth-century wooden cockerels. (Photograph courtesy of Archive of the Art of Maine, Colby College)

57. Weathercock from the vicinity of Bethel, Maine, late eighteenth century. Fully carved on both sides, this dignified bird has evidently been repainted many times.

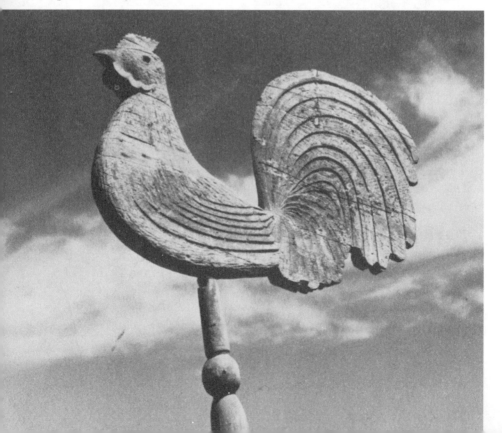

building remained unfinished until 1792, when the steeple was added and presumably also the wooden cockerel that still reminds those who glance upward that "as the vane is true to the wind so should a man be true to his Lord." Cast-metal roosters closely resembling the earlier wooden birds were a standard pattern by the first half of the nineteenth century and were available in several sizes. The large combs and handsome tail feathers were cut out of sheet metal and separately attached to the cast-iron or copper bodies. A typical example of this style is owned by the Abby Aldrich Rockefeller Folk Art Collection in Williamsburg, Virginia, and is illustrated in their 1957 catalogue.

In the 1870s one could order a twenty-four-inch metal codfish from

58. Cod from the Webster farm, East Kingston, New Hampshire. One of three similar fish made by Alonzo Parker during the mid-nineteenth century.

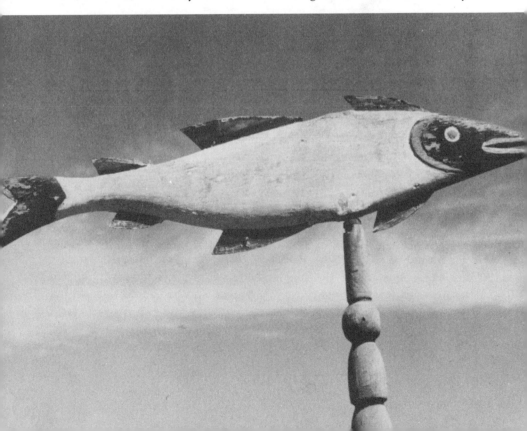

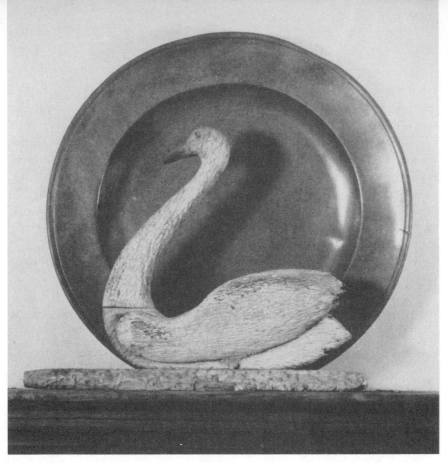

59. Swan mounted on an old board, c. 1850. From a small barn in Peabody, Massachusetts.

a manufacturer for $17.50 and a thirty-inch model for $20.00. Produced by the thousands, they certainly lacked the originality that characterized handmade wooden models. Figure 58 shows one of three similar fish that were installed on neighboring farms in East Kingston, New Hampshire, during the middle of the nineteenth century. Alonzo Parker, known locally as "a seafaring man," was the maker, and he carved them in the round from one large stick of wood. By incising and painting a red gill and eye and attaching black metal fins to the shaped white body, Parker gave distinction to his fish and made them recognizable wherever

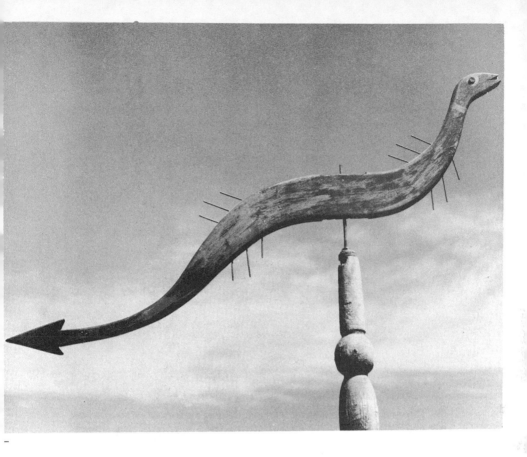

60. Serpent shaped from one piece of wood, second half of the nineteenth century. Interest in this form of vane probably increased following the alleged appearance of a sea serpent in Gloucester Harbor on August 14, 1817.

seen. Another wooden cod of more traditional pattern, said to have been carved in Newburyport, Massachusetts, swung for nearly a hundred years atop a barn on the George W. Adams farm in Byfield, Massachusetts. This vane was mounted in 1858 and remained unpainted for sixtynine years.

Horses with flying manes and tails were undoubtedly the most popular of all weathervanes and many of both wood and metal were copied from contemporary prints of famous racers and trotters. Cows, sheep, and rams were considered suitable ornaments for the large cattle

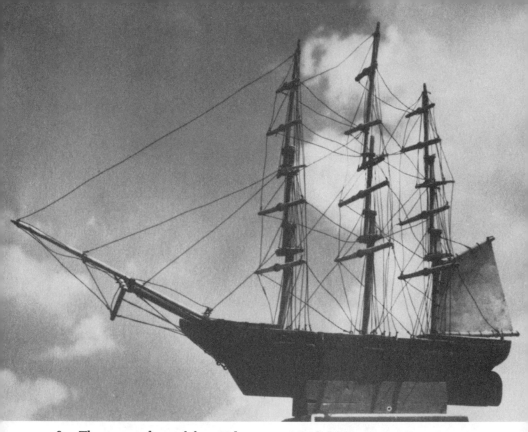

61. Three-masted vessel from Edgartown, Martha's Vineyard, Massachusetts, late nineteenth century. A square-rigger, made of wood with wire shrouds. Commercially made ships cut from metal sheets were also popular, but less interesting than the wooden models.

barns of the late nineteenth century, whereas horses were favored for carriage houses or stables. Much rarer, and now seldom seen, were wooden swans with folded wings. A good example from a small outbuilding in Peabody, Massachusetts, is shown in figure 59. Snakes or serpents were perhaps less pleasing but created effective designs when silhouetted against the sky. The Abby Aldrich Rockefeller Folk Art Collection owns a fine hand-forged snake of early date, while figure 60 presents a sea serpent carved from a single piece of wood with fins and eye of metal.

Seventy-five years ago weathervanes in the form of square-rigged

ships were often to be seen along the New England coast, and were even found in towns many miles from the sea. They were constructed as three-dimensional models with wire rigging, wooden hulls, spars, and sails, and sometimes, at least, were locally made. Traditionally only one stern sail was set, possibly to ensure that the vane did not catch the wind and sail off its pole, but more likely to head it properly into the wind. Figure 61 shows a familiar type that came from Edgartown, Martha's Vineyard, Massachusetts, and probably dates from the 1890s. Another handsome vessel with two sails was made by a retired sea captain for an old house in Ponkapoag, Massachusetts. Eventually outliving its usefulness in the original location, it has decorated the gable of a summer home in Tenants Harbor, Maine, for nearly fifty years. Still a third, recently spotted atop a weathered building near Weathersfield Bow, Vermont, exhibits the unusual feature of a sail with lowered peak as if in anticipation of a coming storm.

One twentieth-century carver merits recognition here because the few weathervanes he made are outstanding for their form and decora-

62. Mallard duck by A. Elmer Crowell, East Harwich, Massachusetts, c. 1920. Fine painting and carving distinguishes Crowell's work.

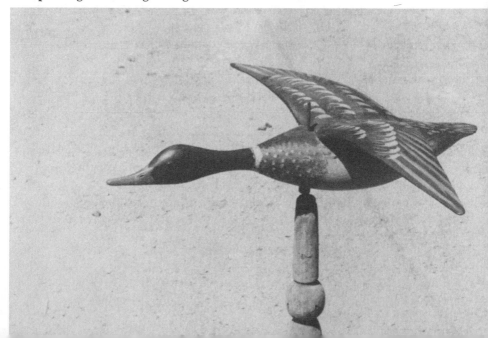

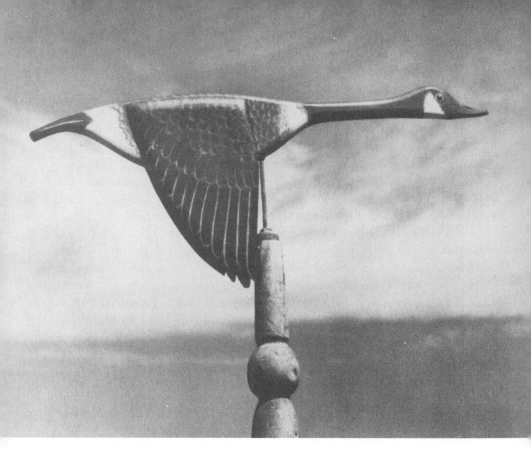

63. Canada goose in flight by A. Elmer Crowell, c. 1920. A rare example of the work of this famous decoy maker who produced few weathervanes.

tion, and they carry on an earlier tradition of wooden vanes. A. Elmer Crowell (1862–1951) was born and spent most of his long life in East Harwich, Massachusetts, and he became known for carving and painting outstanding decoys and shore birds even before the end of the nineteenth century. Crowell is quoted as saying that he made less than a dozen full-bodied duck vanes, no two of which were exactly alike, and that many were never used outdoors but were kept inside as ornamental pieces (fig. 62). A Canada goose, with wings lowered in flight, is another of his remarkable models (fig. 63), a counterpart of which was acquired directly from Mr. Crowell about fifty years ago.

NOTES

1. The Dennis family tape loom is illustrated and discussed in Dean A. Fales, Jr., *Essex County Furniture, A Catalogue of a Loan Exhibition* (Salem, Mass.: Essex Institute, 1965).

2. Nina Fletcher Little, "Carved Figures by Samuel McIntire," *Samuel McIntire, A Bicentennial Symposium* (Salem, Mass.: Essex Institute, 1957), p. 86.

3. Copies of these catalogues are in the Library of the Abby Aldrich Rockefeller Folk Art Collection, Williamsburg, Virginia.

4. J. Rayner Whipple, "Old New England Weather Vanes," *Old-Time New England* (October 1940), p. 45.

SCHOOLGIRL
AND
LADIES' ART

Framed pictures to hang upon the wall, both painted and embroidered, played an important role in home decoration from 1750 to 1850. Because of their ingenuous subjects these pictures are now included under the general heading of amateur art, although ladies' work seldom represents an entirely untrained effort. In fact, the schoolgirls and their mothers who plied the needle or wielded the brush were often experts in their craft.

As early as 1740 one John Waghorne announced in the *Boston Gazette* that he was planning a school for instruction in "the new method of Japanning which was invented in France for the Amusement and Benefit of the Ladies . . . at Five Pounds for each Scholar." This advertisement actually postdated by some fifty-two years a book pub-

lished in London in 1688 by John Stalker and George Parker entitled *A Treatise of Japaning and Varnishing*, which gave full directions for this fashionable pastime, and in addition to the text included twenty-four engraved copperplates to serve as sources of design. Occasionally one sees eighteenth-century artists' boxes with ample compartments for strainers, funnels, vials, gally pots, and brushes that exhibit on their covers japanned landscapes in the Oriental manner, which derive from the Stalker and Parker illustrations.

At the same period private schools teaching the art of pictorial needlework were advertising in the newspapers of the larger seacoast cities. Many pieces were stitched in "cruells" or multicolored "worsted slacks," the designs being drawn on the background fabric by the preceptress from patterns imported from London. Handmade wooden

64. Lucy Palmer's needlework frame, dated 1757. The unfinished embroidery is tacked at top and bottom, and held taut by adjustable wooden pegs inserted in the side bars.

65. Needlework picture to hang above a fireplace. The design was apparently copied from two European engravings and stitched in silk by the daughters of John Scollay of Boston in 1766.

frames were used to insure against puckering and for ease in drawing through the yarn. Heavy linen was first stitched to the top and bottom edges of the canvas foundation of the needlework and was then firmly nailed to the upper and lower bars of the frame. To facilitate stretching the fabric evenly the side bars were made adjustable by inserting hand-whittled wooden pegs into a progression of holes. The frame in figure 64 still contains an unfinished piece of needlework showing part of the basic drawn pattern that was never covered with stitches. One bar of the frame is inscribed in faded ink: *Lucy Palmer 1757.*

Silk floss was also used in the eighteenth century for delicately shaded landscapes. The "chimney picture" in figure 65 is embroidered in silk on a black satin background and dated *1766* in the needlework. This sophisticated design, seemingly copied from two European engravings, descended in the John Scollay family of Boston and is said to have been completed before the Revolution by his two daughters Mercy and Deborah.

As the eighteenth century drew to a close, painting gradually superseded needlework as a medium for pictorial expression. During the transitional period needlework figures often exhibited carefully painted

hands and faces, while watercolor techniques cleverly simulated French knots and other embroidery stitches.

Early in the nineteenth century private boarding schools or academies for young ladies started to multiply, particularly in country towns. These institutions offered a genteel education and occasionally admitted young gentlemen, lodged and taught, of course, in separate buildings from the female scholars. Private homes of suitable size were frequently acquired, and were charmingly depicted by the students. Figure 66 portrays Greenfield High School, Franklin County, Massachusetts, which was established in a Federal mansion in 1828. In 1809 St. Joseph's Academy near Emmitsburg, Maryland, was founded in the fine old building depicted by Anna May Motter in plate 3. Large new structures later dwarfed the original house but the school continues under the name of St. Joseph's College. If a school appeared promising and likely

66. *Greenfield High School for Young Ladies,* c. 1835, by M. D. Belcher, probably a student at the school. Rev. Henry Jones of Hartford, Connecticut, a Yale graduate, was the Preceptor for many years. All branches of female education were taught, there being an instructor for each department. (Abby Aldrich Rockefeller Folk Art Collection)

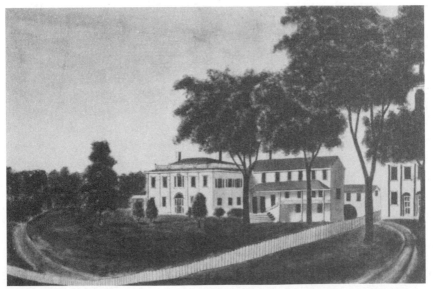

67. Family Memorial to Edmund and Sarah Perley, Lempster, New Hampshire, c. 1840. Monochrome wash drawing. Mourning pictures of traditional design hung in many rural parlors, but the elaborate Victorian-Gothic church, and hearse house with black doors, are unusual elements.

to endure, a building especially designed for its purpose was sometimes underwritten by prominent citizens of the town. Such was the case at Miss Sarah Pierce's Female Academy in Litchfield, Connecticut, which flourished from 1798 to 1833, having in 1819 changed location from Miss Pierce's home to a small building with slender cupola and a pilastered facade.[1] In addition to the basic courses of instruction, which usually included history, geography, and spelling, subjects such as French, music, drawing, or painting were offered at a small extra charge. In

Miss Pierce's painting classes her pupils produced creditable landscapes in both needlework and watercolor; mourning pictures (fig. 67); samplers, which remained popular until the 1840s; historical charts, and handmade bead bags (fig. 68).

68. Bead bag. Fringed bead bags with homemade silk linings are seen in itinerant portraits of the 1830s, but most had floral patterns. This one includes a church, bandstand, houses, and sheep gamboling on the green.

The Vermont Literary and Scientific Institution was located in Brandon, Vermont, during the early 1840s. The brick building that housed the seminary contained a chapel, assembly rooms, laboratory, library, recreation space, and thirty private rooms, each of which accommodated two pupils. These rooms, furnished with a stove, table, bedstead, and chairs, could be engaged for $2.00 per quarter. In Brandon there were separate departments for males and females—eighty-four boys and fifty-five girls, all taught by a staff of five men and women. The academic year consisted of forty-four weeks divided into two terms. English, mathematics, mental and moral sciences, Latin, Greek, and

69. *The Residence of General Washington* by Susan Whitcomb. Watercolor painted at the Vermont Literary and Scientific Institution, Brandon, Vermont, where Susan was a student in 1842. The painting technique simulates embroidery. (Abby Aldrich Rockefeller Folk Art Collection)

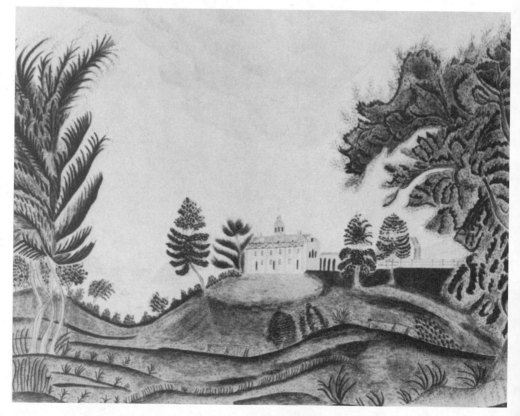

French were among the subjects offered. Drawing or painting was an "extra" costing $1.00, but this modest sum included the "use of patterns."[2] This phrase referred to the designs used in schoolgirl pictures, most of which were copied or derived from prints or book illustrations.

Original work or painting "from nature" was not encouraged, although some of the landscapes based on printed sources far surpassed their prototypes, especially if the young artist happened to possess originality and an innate sense of design. Susan Whitcomb of Henniker, New Hampshire, attended the Vermont Literary and Scientific Institution in 1842 and at that time painted a watercolor view of Mount Vernon that ranks as one of the most spirited examples of seminary art—its rhythmic design exceeding the academic Robertson-Jukes engraving of 1800 from which it derived (fig. 69).

Two well-known private schools were located in the Boston area, and their pupils produced many outstanding pictures. Mrs. Susanna Rowson, like numerous other refined ladies in impecunious circumstances, advertised in the *Columbian Centinel* in November 1797, that "she purposes instructing young ladies in Reading, Writing, Arithmetic, Geography and needle-work," and she offered to board and lodge a few scholars in her own family. Mrs. Rowson's venture was so successful that in 1803 "Painting and Drawing, Flowers, Landscape and Figures" were among the subjects added at extra charge to the curriculum. An artless example of children in a bucolic setting illustrates a combination of painting and needlework that was done by Caroline Jackson at Mrs. Rowson's Academy and is so identified on the original black glass mat (fig. 70). With moves to several different locations near Boston, this school continued successfully until Mrs. Rowson's retirement in 1822[3] (fig. 71).

Equally well known was the academy kept by Mrs. Saunders and Miss Beach where, according to tradition, only the daughters of merchants were eligible to attend. The square hip-roof house, later used as a private residence, still stands on its original site, but shorn of the surrounding open fields and fine view of Boston and the Bay. On March 29, 1809, the *Columbian Centinel* carried the following notice: "Mrs.

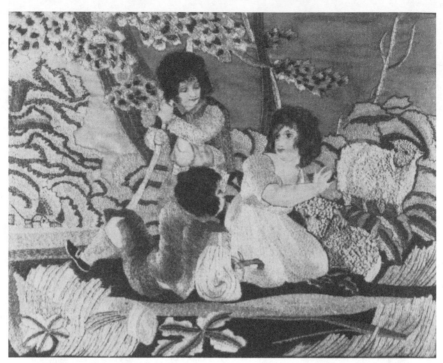

70. Needlework by Caroline Jackson at Mrs. Rowson's Academy. Caroline was a pupil there before 1804, her address was listed as Little Cambridge. (Old Sturbridge Village)

Saunders and Miss Beach continue to instruct young Ladies at their House, near the Rev. T. M. Harris's Meeting House, in Dorchester." Among the thirteen subjects offered here were the specialties of Letter Writing, Needlework, drawing of maps and charts, and Painting in oil, watercolor and crayons. These "branches" cost $6.00 per quarter. Board was $30.00 and washing was 50¢ per dozen items. In later years Mrs. Saunders was remembered as being feared by the girls because she saw everything but excused nothing. Miss Beach, on the other hand, was gentle and imaginative and a favorite with the pupils.[4]

A beautifully executed picture done in needlework illustrates an episode from the story of Hagar and Ishmael; it was worked by Eunice

Bent at the Saunders and Beach Academy. An even more impressive composition features Petrarch testifying before Cardinal Colonna in a curtained interior with painted columns and a floral carpet in the foreground (fig. 72). This carries the name of Nancy Lee and a notation on the reverse, which reads: "Wrought in 1804, 16 yrs. Nancy Lee born 1788, died 1865." Identification of the artist and school is expertly lettered on the white-enameled glass that surrounds the subject, and the original frame, handsomely carved and gilded, includes a rope molding.

Although young ladies were taught to gild their own frames and to decorate the black mats in vogue in the early nineteenth century, professional framers were frequently employed by the parents of gifted academy pupils. This is proved by many entries in the daybook of John Doggett, an early nineteenth-century carver, gilder, cabinetmaker, and looking glass manufacturer of Roxbury, Massachusetts. One of his ledgers, covering the years from 1803 to 1809, lists many picture frames

71. Mrs. Susanna Rowson's Academy on Boston Neck. The school occupied these premises between 1807 and 1811. Watercolor probably done by a pupil. (The Bostonian Society, Old State House, Boston)

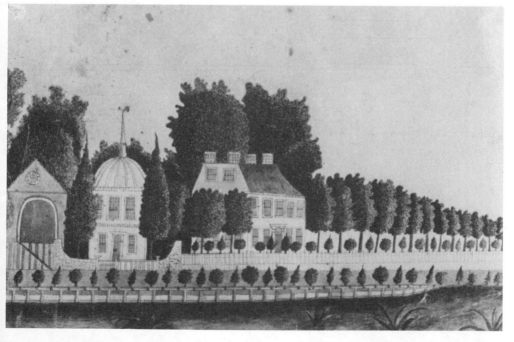

72. *Petrarch Testifying Before Cardinal Colonna,* 1804. Needlework on silk, wrought by Nancy Lee at the Saunders and Beach Academy. The carved and gilded frame was probably supplied by John Doggett of Roxbury, Massachusetts.

and glass mats supplied to his large clientele in Boston and vicinity. In 1806 Mr. Bent of Milton, father of Eunice mentioned above, purchased a sampler frame and glass for the modest sum of 84¢, which he paid for by bread credited at the same price. In 1805 one Dr. Williams paid $10.50 (a relatively large amount) for an embroidery frame and glass with lettering and enameling for Mary Bliss, and there are many charges for "stretching" and "straining" pieces of needlework. Mrs. Rowson's name appears on several entries in the Doggett book in connection with her school.[5]

Labels of picture framers other than Doggett prove that many of them were also looking glass makers. Spencer & Gilman of Hartford, Connecticut, inserted several advertisements in the *Connecticut Courant* between 1816 and 1819. They sold looking glasses as well as artists' supplies, such as painters' tools and camel's hair brushes, and also featured framing of "pictures and embroidery." A pair of watercolors, one bearing a Spencer & Gilman label, is owned by the New York State Historical Association, Cooperstown, New York. Two other framing establishments were Kidder & Carter of Charlestown, Massachusetts, and William Cunnington, carver and gilder, whose name is listed in the Boston street directories from 1806 to 1810. Labeled frames on watercolor and needlework pictures by these makers are owned by the Abby Aldrich Rockefeller Folk Art Collection, Williamsburg, Virginia, and other examples have been found by individual collectors.

The genealogical record of the Howe and Richardson families illustrated in figure 73 is a skillful example of pen-and-wash drawing, signed by John Howe and dated 1803. The carved frame is very similar in many respects to that on Nancy Lee's picture of Cardinal Colonna and carries Doggett's label on the reverse (fig. 74). John Howe (1779–1828) may have been a teacher of drawing and calligraphy. He appears in the Doggett ledger in 1804 charged with the purchase of two portrait frames for $10.67.

The names of many less prominent schools, such as Cedar Grove, Kentucky, Miss Sampson's in Hingham, Massachusetts, and S. Swan's school in Medford near Boston, are chiefly remembered today by the

73. Record of the Howe and Richardson families of Boston by John Howe, 1803. Pen-and-wash drawing. The frame was made by John Doggett.

74. John Doggett's label on reverse of figure 73.

inscriptions found on their pupils' art. Academies, however, were by no means the only source of art instruction. Independent drawing schools were taught by many professional artists as an outside activity to augment their incomes or to gain a larger clientele.

On March 6, 1793, one Samuel Folwell announced in the *Pennsylvania Packet* that he was soon to open a drawing school for young ladies in Philadelphia. Thirty pupils were solicited to be divided into three classes, each meeting three half days per week at a fee of $8.00 per quarter. Art instruction consisted of the following subjects: all kinds of pencil work; painting upon satin, ivory, or paper; and work in human hair. Five years earlier S. Jennings, who listed himself as a painter of miniatures, portraits, and pastels, advertised, in Philadelphia, a drawing school for both ladies and gentlemen, the former to meet from eleven to one every other day and the latter from six to eight every other evening. New England towns also had local drawing schools. George Dame published a lengthy advertisement in the *Portsmouth* [N.H.] *Oracle* on March 29, 1806, describing himself as a portrait, miniature, coach, and sign painter and announcing a Drawing School "to commence April 17th if sufficient encouragement." In the same town, during 1825, John S. Blunt (regarded today as a leading landscape and marine painter) advertised in the *New Hampshire Gazette* on April 5, a Drawing and Painting School to teach "oil painting on canvas and glass, water colours, and with crayons." Individual instruction at home was also possible, and one matron living in rural New Hampshire arranged for a drawing master to come up periodically from Boston to teach her daughter flower painting.

Not all pictorial decoration wrought at schools resulted in framed pictures to hang upon the wall. Some of the most delightful examples of ladies' work include furniture and domestic accessories. Shaped fans to shield the face from a hot fire were favorite subjects for the amateur's brush. The dainty example on the left of figure 75, with gilt paper binding and stenciled border, was decorated by Miss Jane Johnson Hatch of Alfred, Maine, presumably while she was a student at Bradford Acad-

75. Three fire fans, second quarter of the nineteenth century. At left, water-color on cardboard, stenciled by Jane Johnson Hatch of Alfred, Maine. In center, a double-faced fan painted freehand. The fan at right is stenciled on wood with gilded corners.

emy in Haverhill, Massachusetts. Many elements in similar compositions involved the use of "theorems" or stencils. By combining several hollow-cut patterns, quite intricate designs could be successfully painted on the surface below, even by relatively inexperienced amateurs.

Personal sewing equipment was of primary importance to the feminine members of a family, and they often decorated their own sewing boxes. These varied from small, simple receptacles to commodious ones having compartments for pincushion, needles, thread, and beeswax. Octagonal wooden boxes were especially popular and were sometimes covered with plain paper, then finished with floral borders and landscapes in clear, bright colors. Figure 76 shows a good example presenting a romantic scene. A preliminary sketch for a similar cover, painted by a young lady in Newburyport, Massachusetts, circa 1820, appears in figure 77. This sort of picturesque composition was very much in vogue during the early part of the nineteenth century.

Many thread and sewing boxes in natural wood were ornamented with fruit and shell motifs, or with chubby angels playing melodies on harps from heavenly music scores. Figure 78 illustrates competently drawn groups of strawberries and shells intended for use as furniture

76. Octagonal sewing box, c. 1820. Painted with an English scene derived from a printed source.

77. Preliminary watercolor sketch for the top of an octagonal box by a young lady from Newburyport, c. 1820. This picturesque scene was presumably copied from an illustration in a drawing instruction book.

78. Vignettes of berries and shells, 1810–1825. Two amateur sketches to be copied onto furniture.

decoration. Similar shells by a less-experienced hand form a decorative band in figure 79. The inscription on the bottom reads: *Miss Sarah McCobb's, painted by Miss Jane Otis Prior March 1822. Remember your friend Jane when far distant from each other when you look at this.* The box, obviously a personal gift, was probably decorated at Miss Tinkham's School in Wiscasset, Maine, where needlework and painting on velvet were also taught for $3.00 to $6.00 per quarter.

Decorating sewing stands and dressing tables was a more ambitious project because the latter sometimes had matching boxes for gloves or other articles of apparel. The curly maple table and matching box illustrated in figure 80 were ornamented by Miss Sarah Bass Foster, daughter of a Revolutionary patriot, the Reverend Edmund Foster of Littleton,

79. Sewing box with view of Front Street, Thomaston, Maine. Painted by Jane Otis Prior, 1822. Shells were favorite schoolgirl motifs.

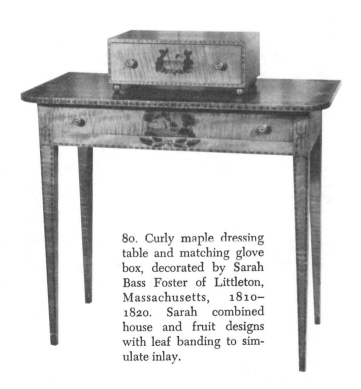

80. Curly maple dressing table and matching glove box, decorated by Sarah Bass Foster of Littleton, Massachusetts, 1810–1820. Sarah combined house and fruit designs with leaf banding to simulate inlay.

Massachusetts. It should be emphasized, however, that all painted furniture of this type was not ladies' work, some of the more expert examples being the products of professional decorators.

Young students were seldom trained or expected to originate their own designs, the emphasis in both needlework and painting being on the quality rather than the originality of the work. It is obvious that patterns for copying were provided in most schools but there is very little information about where and how these were acquired. One important source of both instruction and design was to be found in the vast number of drawing books that were imported from England and published in

81. Top of a sewing table. Painted by Sarah Eaton at Mrs. Rowson's Academy, c. 1810.

82. Illustration from J. T. Bowen's *United States Drawing Book* (1839). Picturesque scenes like this were adapted for furniture decoration during the first half of the nineteenth century (see figure 81).

America during the first half of the nineteenth century. Many were composed for adults, others were written and illustrated for children. A few of the diverse subjects covered by these books are suggested by the following titles: *A Drawing Book of Landscapes*, 1810; *Drawing Book for the Amusement and Entertainment of Young Ladies and Gentlemen*, circa 1816; *Drawing Book of Flowers and Fruits*, circa 1837, all three published in Philadelphia; *Drawing for Young Children*, Boston; *Drawing Book of Trees*, Hartford, both issued in 1841; *Easy Lessons in Landscape Drawing with sketches of animals and rustic figures*, Hartford, 1840. Included in their texts—aimed directly toward home instruction— were copious illustrations intended as models for inspiration or copying. Many United States drawing book illustrations derived from English

instructors that leaned heavily on the cult of the picturesque. Therefore, romantic castles, thatched cottages, crumbling ruins, stone bridges, and wooden waterwheels often appeared as prominent features in American schoolgirl art. Figure 81 illustrates a sewing table top painted by Sarah Eaton of Dedham, Massachusetts, while a pupil at Mrs. Rowson's Academy. This is a superior example in freehand, but the inspiration obviously came from an instruction book. The interesting comparison in figure 82 is found in J. T. Bowen's *United States Drawing Book*, Philadelphia, 1839. Of Bowen's book Carl W. Drepperd writes: "Bowen's collection of landscapes . . . apparently motivated the drawing and

83. Mahogany painting box owned by Miss Caroline Shetky of Philadelphia and Boston, c. 1830. The drawers still contain her graduated ivory palettes, drawing pens, and brushes. Several cakes of paint are stamped *Winsor and Newton, Rathbone Place*.

84. Chinese lacquer sewing box with painting equipment in lower drawer. Brought to America about 1820 by way of the China trade. The old watercolors are in their original blanc-de-chine cups. (Collection of Carl L. Crossman)

painting of hundreds of landscapes in their pattern and form. Even now, over a century after its publication, amateurs' oils and watercolors . . . as done by Bowen, can be found among the 'Primitives' in many shops and galleries."[6]

Ladies' painting boxes present a fascinating study in themselves. Although many have now disappeared or have been put to other uses, enough survive in unaltered form to indicate the great variety that once existed. Some were fine examples of cabinetmakers' skill, fitted with drawers for brushes, paint, and other equipment. The well-equipped box in figure 83 belonged to Miss Caroline Shetky, miniature, landscape, and still-life painter of Philadelphia who married Samuel Richardson and moved to Boston after 1825. A few lucky artists owned Oriental boxes brought home in the China trade. Figure 84 illustrates a beautiful combination sewing and painting box of black and gold lacquer; the lower drawer still contains the original brushes, sealing-wax sticks, and porce-

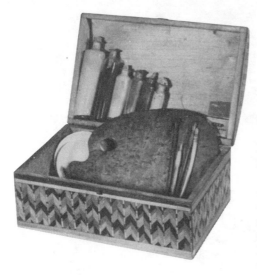

85. Straw-covered box and separate palette owned by Mary Nettleton and carried from Connecticut to Ohio in 1839. Mary's stencils, paints, and brushes evidence what was needed for amateur flower painting. Her tuition at Wesleyan Academy for the fall term of 1834 totaled $3.75.

86. Mid-nineteenth-century paint box sold by Reeves & Sons, London. English boxes of this type were popular here because of the snob appeal of "London Colours." The corner of a similar box appears in a still-life composition comprising a landscape with painting equipment, signed by Edwin Whitfield in 1840.

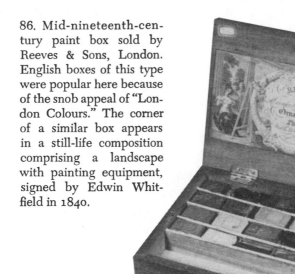

lain saucers filled with old colors. But much ladies' equipment was assembled at home, such as the contents of the straw-covered box shown with a small maple palette in figure 85. Still filled with an odd variety of blown-glass bottles containing powdered colors, earthenware mixing saucers, a bundle of assorted brushes, and approximately sixty stencils for creating fruit and flower pictures, it was taken from Connecticut by Mary Nettleton when she married and moved to Portage County, Ohio, in 1839. Mary attended Wesleyan Academy (established first in New-market, New Hampshire), and with the box is one of her stenciled wreaths.

Many decorative still-life pictures painted in oil or watercolor on velvet, canvas, and wood are still found (plate 4). Brushes and colors were obtainable at city shops and painters' materials were also sold by professional artists and drawing teachers. The makers of English boxes used in America were identified by stylish labels that impressed the purchaser with the superiority of imported goods (fig. 86). This led at least one Connecticut artist, Major Moulthrop of New Haven, to label his modest boxes *London Colours*. His colored powders, especially prepared for fruit and flower painting, were contained in small glass bottles molded with his initials on the sides.

Whether accomplished or naïve, melancholy or gay, the pictures painted by amateurs are usually pleasurable to the eye, and demonstrate the high quality of work accomplished by women and young people during the eighteenth and first half of the nineteenth centuries.

NOTES

1. Emily Noyes Vanderpoel, comp., *Chronicles of a Pioneer School*, 2 vols. (Cambridge, Mass.: 1903).

2. The catalogue of the Vermont Literary and Scientific Institution is in the library of the Abby Aldrich Rockefeller Folk Art Collection, Williamsburg, Virginia.

3. For further details concerning Mrs. Rowson's school see Jane C. Giffin,

"Susanna Rowson and her Academy," *Antiques* (September 1970), pp. 436–440.

4. Personal recollections of a pupil in the school are a part of an old label pasted to the wooden backing of the frame of a Saunders and Beach picture.

5. The Doggett daybook is in the library of the Henry Francis du Pont Winterthur Museum, Delaware.

6. Carl W. Drepperd, *American Drawing Books* (New York: The New York Public Library, 1946). The Print Department of The Metropolitan Museum of Art, New York, contains a comprehensive collection of English and American drawing books.

PICTURE FRAMES WITH PAINTED DECORATION

Molded enframements of various kinds have been used in America since the seventeenth century to protect and enhance the pictures with which they were associated. The utilitarian aspect of the frame was emphasized in an advertisement that appeared in the *Maryland Journal* of November 9, 1792, when one William Faris of Baltimore announced the establishment of a Looking Glass Factory on Calvert Street. Like many looking glass makers he also made frames that were glazed "so as to prevent Dust or Insects from injuring the pieces."

In addition to being useful, frames also provided colorful and decorative finishes for paintings or prints. As artistic taste changed following prevailing fashion, they underwent modifications in design and bore a definite affinity to the contours of architectural moldings of successive periods.

87. Detail of marbleizing on frame of portrait of Rev. Caleb Turner of Middleboro, Massachusetts, by Rufus Hathaway, 1791. (Old Colony Historical Society, Taunton, Massachusetts)

88. Detail of freehand painted frame, c. 1800. Shaded gold on a black background.

The majority of pre-Revolutionary frames appear to have been painted black or finished in gold leaf. William Faris and others made them to order—any size or pattern, with members plain or carved, black or gilt. In the country, however, less sophisticated examples followed the style of painted decoration to be found on contemporary grained and marbleized woodwork and furniture.

To document the makers of ornamental frames is not an easy task, as most identified examples bear the labels of professional looking glass makers and illustrate the arts of the carver and gilder rather than of the artisan painter. Many early portraits have lost their original surrounds,

89. Detail of frame with brown sponging on a buff background. Portrait of Cyrus French, Grafton, Massachusetts, 1786.

but enough survive to show the varied effects used during the last quarter of the eighteenth century. The heavy molding in figure 87, with its black veining on a buff ground, is very similar to marbleized bolections found on Georgian chimney breasts. The portrait it contains was signed and dated 1791 by Rufus Hathaway of Duxbury, Massachusetts, who used this type on several of his earliest pictures.

A more delicate technique applied to a few eighteenth-century frames consists of freehand painting in gold on a black ground. A group of portraits, painted by an unknown traveling artist in Sudbury, Massachusetts, exhibits decoration with dainty gold corner pieces in the form of flower sprays. Slightly later is a graceful running-leaf pattern expertly painted in shaded gold (fig. 88).

The art of mottling was a technique employed in both the eighteenth and the early nineteenth centuries, a good example of which may be seen in figure 89. Convex moldings are typical of this period, although they are not so bold as the bolection example in figure 87. The portrait

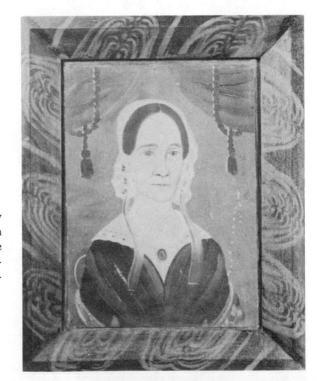

90. Frame with yellow swirls on a dark reddish background, c. 1840. The lady is painted on cardboard, school of William M. Prior.

depicts Cyrus French of Grafton, Massachusetts, dated 1786. The dark brown sponging is on a buff background. The mottling of a generation later is illustrated in plate 5, where black on mustard yellow sets off the stylish hollow-cut profile.

During the early years of the nineteenth century, when art instruction formed part of a genteel education, picture frames were often painted by amateurs. The lady with the orange dress and the blue scarf is greatly enhanced by her frame, which is touched with complementary colors (fig. 90). Reeded moldings in the Neoclassic taste were considered particularly appropriate for watercolor compositions, such as the artless bunch of flowers in figure 91, where the frame is picked out in brown, blue, and tan to emphasize the colors in the spray. Original frames with alternating bands of green and yellow have been found on several velvet fruit pieces, making a harmonious whole.

The second quarter of the nineteenth century ushered in a more flamboyant period in painted decoration. Gradually painting ceased to

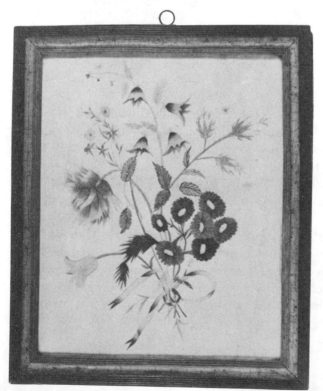

91. Spray of flowers by a young lady of the Adams family, Byfield, Massachusetts, c. 1815. The reeded frame echoes predominant shades in the watercolor.

92. Shadow box frame, stenciled in colors on the natural wood, first quarter of the nineteenth century.

simulate the exact appearance of marble or grained wood and became purely decorative in effect. Ornamental frames in fanciful designs added interest and variety to the folk portraits of the 1830s (plate 5). The wide, flat molding of the 1840s in figure 91 is stained a rich brownish-red, creating a perfect background for swirled motifs in orange-yellow. It is reminiscent of many others—all similar in feeling but different in detail.

In some instances artists supplied individual frames to their sitters, although many ornamental ones were undoubtedly executed in the home. Early examples were seldom signed so information concerning decorator and place of origin is almost nonexistent. During 1822 and 1823, however, one Chapman Lee, a country cabinetmaker in Charlton,

Massachusetts, listed in his daybook "likeness and landscape frames" by the dozen for which he charged twelve to thirty-five cents apiece whole-sale.[1] These he sold to Harvey Dresser, a local painter-decorator, who presumably embellished them for the retail trade.

The first half of the nineteenth century was the great period of

93. Stenciled frame original to the portrait of an unidentified lady by Erastus Salisbury Field, c. 1837.

stenciled decoration. Stencils (also used to ornament furniture, accessories, floors, and walls) appeared on picture frames and were combined to create many different effects. Some of the stenciling found on small household objects was apparently ladies' work. Figure 92 illus-

94. Captain David Ockington, Jr., in an 1830 eagle-stenciled frame. Ockington was first mate on the ship *Commerce* of Salem, when, as a young man, he was shipwrecked off the Arabian coast in 1792.

95. Pair of stenciled frames by Anson Clark, West Springfield, Massachusetts, c. 1830. The Channel family records (not original to the frames) were painted by William Saville, a Gloucester, Massachusetts, schoolmaster in 1792.

trates one side of a shadow box that contains a dainty arrangement of cut-paper flowers.

Bronze powder applied through stencils to a slightly tacky surface below was the customary procedure, and produced what is commonly known as gold stenciling on the majority of frames. Large oil portraits, engravings, still lifes, and small silhouettes were among the subjects enhanced by this type of work. The artist Erastus Salisbury Field, who traveled from town to town in central Massachusetts, is thought to have supplied a few special clients with frames such as that in figure 93. The unusual example in figure 94 displays patriotic symbols typical of the early Republic, quite appropriate for the sea captain who nearly lost his life in a shipwreck off the coast of Arabia in 1792.

Decorators' names are always of special interest. The documented pieces in figure 95 descended in the family of Anson Clark, a stenciler

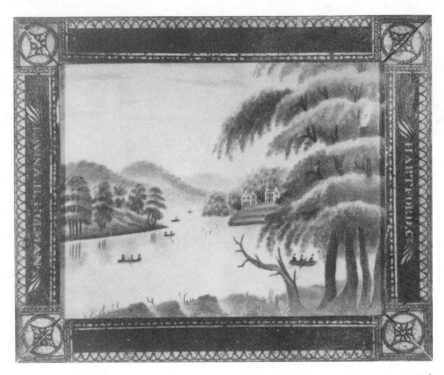

96. Rare stenciled frame, c. 1840, bearing the artist's name, *Lavinia H. Holman/Hartford. Ct.*

of West Stockbridge, Massachusetts, who worked circa 1830. They comprise two of a group of five, each different but related in design. All employ floral rather than geometric units that are well spaced and exhibit particular precision and clarity. The only signed frame known to me encloses a naïve black-and-white river scene typical of schoolgirl pastels of the early 1840s (fig. 96). One supposes that the picture and its surround were both executed by the same hand.

Silhouettes have long been prized for their ornamental mounts, frequently displaying graceful gilt borders and corner pieces painted on the reverse of the black glass mats. Other profiles, enlivened with a wide variety of decoration, are found (fig. 97). The boy at the left displays freehand work; while the young lady at the right is one of a

pair dating to the early 1830s and acquired many years ago because of the charm of the small stenciled frames.

From time to time folk artists avoided trouble and expense by painting decorative borders directly on the canvas. Occasionally these enframements consisted of a receding band of color, as in the blue and gold edging of Erastus Salisbury Field's *Garden of Eden* (c. 1860) in the collection of the Shelburne Museum, Shelburne, Vermont. In other instances boldly conceived designs provided eye-catching foils to fanciful land or seascapes (fig. 98).

It is, however, the ingenuous trompe-l'oeil frames, really intended to fool the eye, that reemphasize the almost magical qualities of the painter's brush. A good example is the fireboard illustrated in figure 99. It was obviously intended to represent a painting of Mount Vernon with a period frame resting on the hearth, and supported by andirons emerging from the cutout slots below. Another in plate 6 displays simulated carving that is highlighted skillfully on each member of the frame.

97. Silhouettes in gold-painted frames. Freehand and stenciled decoration provide an interesting contrast on these 1835 profiles.

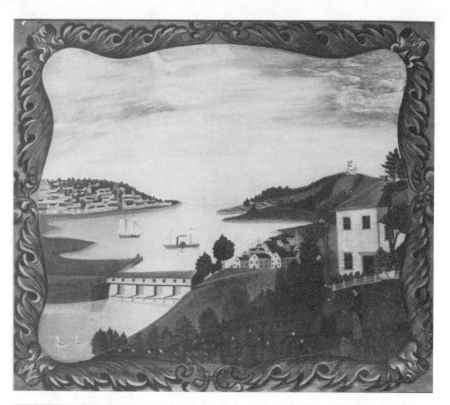

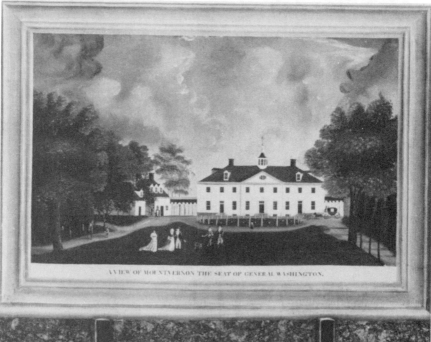

A VIEW OF MOUNT VERNON THE SEAT OF GENERAL WASHINGTON.

After 1850 conventional picture frames soon supplanted the colorful efforts of the fancy painter, their ornate gilt moldings reflecting the taste of the Victorian period.

NOTE

1. Chapman Lee's daybook is in the library of Old Sturbridge Village, Sturbridge, Massachusetts.

98. Fireboard: *River With Covered Bridge,* c. 1825. The painted molding serves as a frame. (Society for the Preservation of New England Antiquities)

99. Fireboard: *A View of Mount Vernon,* American School, late eighteenth century. The gold frame is painted on the canvas to simulate a picture resting on andirons. (National Gallery of Art, Washington, D.C.; Gift of Edgar William and Bernice Chrysler Garbisch)

FLOWERS
IN
THE PARLOR

One of the earliest activities of civilized man was the cultivation of a garden. The use of flowers in the home, however, has undergone many changes. Strewn on the tables of European royalty during the Middle Ages, flowers emerged in small, tight bouquets in mid-nineteenth-century American parlors. The vogue for artificial flowers also should not be overlooked. As early as the seventeenth century blossoms were cleverly copied in Europe to rival the elegant and fragile ones imported from China.[1] The "bosom flowers" used with eighteenth-century American costumes were definitely unreal—either imported from abroad or fabricated here by professionals. The name of Mrs. Geyer of Pleasant Street, Boston, appears as "Flower-Maker" in the *Boston News-Letter* of July 2, 1772. Table arrangements of colorful blooms were also simu-

lated; they were beautifully modeled in German and English porcelain and piled high in deep, openwork ceramic dishes.

Despite such frivolities the eighteenth century witnessed an increasing concern with art-in-nature, and one aspect of this was expressed in the adoption of natural rather than formal garden design. This new enthusiasm brought a growing appreciation of the use of flowers as decoration in the home. English potters were quick to grasp the significance of the newly fashionable trend, and they introduced various ornamental containers for both English and American buyers that were admirably suited to the purpose. Many ingenious devices were incorporated to support the stems and thereby to assure attractive and lasting arrangements.

Antique flower holders divide themselves into four general classifications: pots designed especially to contain cut flowers; to support crocus or hyacinth bulbs; to hold boughs or flowering shrubs; and vases to display informal bouquets.

A particular interest in horticulture was held by the famous potter Josiah Wedgwood, whose son John was one of the founders of the Royal Horticultural Society of London, and whose daughter became the mother of the English naturalist Charles Darwin. Wedgwood made a special study of flower arrangement, which he defined as "the art of disposing the most beautiful productions of nature in the most agreeable, picturesque, and striking manner to the eyes of the beholder."[2] His love of growing plants led him to produce some of the most interesting ceramic containers potted during the last quarter of the eighteenth century. A few for the mantel were purely ornamental, but the majority were as practical as the vases we use today. Many of his contemporaries followed Wedgwood's lead so there was no dearth of imported items for use by the American housewife.

An early form of holder, certainly among the most charming, was the cornucopia, designed in complementary pairs to hang flat against a wood or plaster surface (fig. 100). The Thomas and John Wedgwood "crate-book" records a sale in September 1770, of "10 Corna Copiaes" for the sum of 34 pence.[3] These so-called wall pockets, made in various

100. English salt-glazed wall pocket in the form of a cornucopia, c. 1760.
(Flower arrangement by Georgiana Reynolds Smith)

bodies including creamware and salt glaze, appeared simultaneously in
English prints and American parlors. They were filled with nasturtiums
or other garden flowers. When Richard Olney of Providence, Rhode
Island, died in 1795, his "old fashioned" possessions included "1 stone
hanging flower pot"—probably a salt-glazed pocket similar to that in
figure 100.[4]

About 1750 English delft flower bricks were made in the shape of
small, rectangular boxes with perforated tops to hold stems. Produced
at Lambeth, Liverpool, and Bristol, a few are found with a square hole
for an inkpot and small openings for sharp quill pens.

Some of the most popular pots were molded with bow fronts and
made as three-part mantel garnitures at the turn of the nineteenth cen-

tury. Manufactured in both porcelain and fine quality earthenware they occasionally exhibited fitted covers designed to hold either bulbs or cut flowers. A set of three tulip jars, circa 1800–1820, by the Staffordshire maker William Baddeley of Eastwood is shown in figure 101. The unglazed stoneware body is embellished by delicate molded reliefs in blue and brown and the pierced tops are enlivened with pert green dolphins. The two smaller pots may be placed back to back to form a circular table decoration.

An ingenious device to accommodate both flowers and bulbs is seen in figure 102. Made at the small porcelain factory of Pinxton in Derbyshire, circa 1800, it displays a rural landscape complete with English country house. The cover has appropriate apertures for five bulbs and seven stems. The inside bottom of the pot is fitted with seven porcelain tubes, one-half inch in height, to hold the ends of the stalks at the proper angle.

Most humorous among cut-flower containers were the hedgehogs with deep matching trays for holding water. They are said to have held

101. Three-piece mantel garniture, by William Baddeley, Eastwood, Staffordshire, early nineteenth century. The tops are pierced to support tulips or other cut flowers.

102. Porcelain mantel pot, Pinxton, Derbyshire, c. 1800. The top accommodates either bulbs or flower stems.

flowers or crocus bulbs (which Wedgwood did not consider in the best of taste). Occasionally rolled paper spills were substituted for flowers to provide the porcupine's traditional spiky appearance. During the late eighteenth century hedgehogs were made in green-glazed earthenware or black basalt, but the Staffordshire example in figure 103, circa 1830, carries a pseudo-Chinese scene printed in lavender transfer.

During the early nineteenth century shrubbery and potted plants became enjoyable elements in American homes. The 1816 parlor of Mrs. Elizabeth Cooper, mother of the author James Fenimore Cooper, in Cooperstown, New York, reveals several interesting horticultural arrangements (fig. 104). At the far end of the room numerous square tubs of greenery, resembling asparagus gone to seed, are warmed by sunlight from two tall windows. A slender stand by the door holds a single plant, and Mrs. Cooper is featured at the center with a conventional urn of flowers at her knee.

Shallow ceramic pans in graduated sizes were made for the display of myrtle or evergreens, and eighteenth-century fashion also decreed

103. Hedgehog and tray. Lavender transfer-printed Staffordshire, c. 1830.

104. *Mrs. Elizabeth Fenimore Cooper,* painted in her home in Cooperstown, New York, by George Freeman, 1816. Green shrubbery in tubs fills the end of the room. (New York State Historical Association)

105. *Mr. Foote in the Character of Major Sturgeon.* Mezzotint engraving by J. Boydell after Zoffany, 1765. This print illustrates the English practice of placing boughpots on the hearth. (The Colonial Williamsburg Foundation, Williamsburg, Virginia)

that metal pots of shrubbery or leaves be placed before an unused grate or fireplace. This custom is still observed in the British Isles. On July 29, 1772, Wedgwood wrote to his partner Thomas Bentley, "Vases are furniture for a chimney piece, bough pots for a hearth . . . I think they can never be used one instead of the other." A boughpot is featured in a 1765 English engraving (fig. 105), and the placing of flower arrangements on the hearth was perpetuated in America during the early nineteenth century by paintings on many American fireboards.

Toward the end of the 1700s ornamental jars, called *cache-pots* (cachepot in English) by the French, were made in many forms. In

figure 106, painted circa 1785, Mrs. Mary Kimberly Reynolds of West Haven, Connecticut, sits by a mahogany side table, a decorative pot with a flourishing plant at her side. Hartley, Greene, & Co., among other English firms, produced creamware plant holders at Leeds in Yorkshire, some of which had delicately pierced rims combined with ornamental

106. *Mrs. Mary Kimberly Reynolds.* Painted in West Haven, Connecticut, c. 1785, with a plant in an ornamental white pot beside her.

107. Creamware plant holder, Leeds Pottery, Yorkshire, c. 1790. Decorative containers designed to hide mundane earthenware pots were made in France and England and exported during the late eighteenth century.

108. Hanging flowerpot, American, third quarter of the nineteenth century. Brown-mottled orange glaze. The turned pendant, fluted rim, and incised bands are pleasing features.

banding (fig. 107). The late eighteenth-century inventory of Joseph Brown of Providence listed a number of special household ceramics conveniently stored in a bedroom closet. Included in this varied assortment were a pyramid (for molding jelly) and a cream-colored candlestick and flowerpot.[5]

American flowerpots were made of red earthenware and mass-produced at many small potteries, their countless variety offering a wide choice of shapes for country homes and farms. Some were hand-turned with matching saucers, later machine examples had their bases attached. Hanging holders for vines, with ruffled rims and ornamental pendants, were also made—their lustrous black, brown, and mottled glazes catching the light when suspended from window or ceiling hooks (fig. 108).

Ceramic vases—adaptable to many requirements—have retained

their popularity to the present day. In an era when Marie Antoinette played at country pastimes in the palace at Versailles, it was fashionable for fine ladies in New England to pose in the artless guise of flower arrangers. Mrs. George Watson and Mrs. Benjamin Blackstone were

109. *Unknown Woman* by Joseph Blackburn, third quarter of the eighteenth century. Ladies arranging flowers were painted by several artists of the day. (The Brooklyn Museum, Brooklyn, New York; Dick S. Ramsay Fund)

portrayed in this pose by John Singleton Copley during the 1760s, the former putting finishing touches to a posy in a vase of blue and white porcelain, the latter to a bouquet of pink, blue, and white blooms in a tall glass tumbler. An unknown lady, painted by Joseph Blackburn (fig. 109), holds a single tulip, placing it with others in a vase that was one element of a five-part mantel garniture.

To keep flowers "distinct and clever" quintal flower horns were offered in the 1780s, and illustrated under that name in the *Leeds Pattern Book* of 1783.[6] Disregarded by horticulturists for over two hundred years, the design of radiating spouts still lends itself to graceful arrangements, and good reproductions may be found in some of the larger museum craft shops (fig. 110).

During the second quarter of the nineteenth century artistic bouquets of colorful posies were to be discovered in numerous country houses. One sees them placed on tables and mantelpieces, note John Lewis Krimmel's *The Country Wedding*, as early as 1813 (fig. 111). Simultaneously, footed vases of naïve design but Neoclassic inspiration appeared in drawing instruction books and schoolgirl art (plate 7), thereby adding to the growing appreciation and importance of flower arrangements in the smaller American home.

110. Quintal flower horn, late eighteenth century. Simple arrangements of garden flowers are still attractive in these old-time vases.

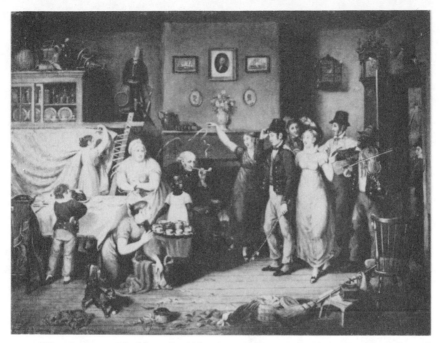

111. *The Country Wedding* by John Lewis Krimmel, 1813. In this informal Pennsylvania room a vase of flowers occupies the place of honor on the mantelshelf. (The Henry Francis du Pont Winterthur Museum, Winterthur, Delaware)

NOTES

1. Georgiana Reynolds Smith, *Table Decoration* (Rutland, Vt., and Tokyo, Japan: Charles E. Tuttle Company, 1968), p. 88.

2. *Old Wedgwood,* A review published annually by the Wedgwood Club [Boston], April 27, 1935, p. 38.

3. Arnold R. Mountford, *The Illustrated Guide to Staffordshire Stoneware* (New York and Washington, D.C.: Praeger Publishers Inc., 1971), plate 156.

4. Barbara Gorely Teller, "Ceramics in Providence, 1750–1800," *Antiques* (October 1968), p. 575.

5. *Ibid.*, p. 577.

6. Donald Towner, *The Leeds Pottery* (London: Cory, Adams & Mackay Ltd., 1963), items in the *Pattern Book* are illustrated following p. 58.

SMALL OBJECTS
FOR USE
AND
ENJOYMENT

Tiny things have always held a fascination for children and adults alike. It is not surprising, therefore, that they were widely made both in Europe and in America during the eighteenth and early nineteenth centuries, and even before that. *Webster's Collegiate Dictionary* describes a miniature as "a representation on a much reduced scale," thereby defining it as a small counterpart of a full-size object. The word frequently connotes a small painting, but in reality a large variety of articles were made in diminutive size.

Decorative arts of minute proportions may be divided into several classifications, the majority of which were created for the enjoyment of children. In the eighteenth century the word *toy* did not always refer to a plaything but more often to a *trinket* or *trifle* intended for adult

amusement or pleasure. Other small objects were fashioned for actual household use. It has also been surmised that some early miniatures were made to be carried by tradesmen as samples of their wares, or were exhibited by apprentices as models of their skill, but no eighteenth-century records corroborating these practices seem to be readily available.

In considering small objects made for little people, it becomes apparent that so-called miniatures fall into two distinct categories: scaled-down furnishings made for a child to use in everyday life; and the tinier examples related to dolls, dollhouses, and other kinds of play. The former are not treated here as they are part of the larger subject of full-size decorative arts.

Observation of the range of antique handmade playthings reveals that wood and ceramics constitute the two largest groups. Lesser numbers are found in glass, silver, iron, tin, and brass. Furniture exhibits the greatest variation in workmanship and design. If a tiny chest, chair, or desk is carefully constructed with perfect proportions, finish, and detail, we may assume that it was made by a cabinetmaker or experienced craftsman, perhaps for a favorite little friend or grandchild. The form of the fine, small chest of drawers in figure 112 suggests this theory. The frame is mahogany, the secondary wood, pine, and it is joined in the proper eighteenth-century manner. An old letter found in one of the drawers tells its history as a toy. Descended for many generations in

112. Toy chest of drawers, H. 7″. Played with as a child by Dr. Joseph Warren (b. 1741) of Boston. He later lost his life at the Battle of Bunker Hill in 1775.

113. Two, well-proportioned bedsteads, 1800 and 1840. L. 15″ and L. 14″. The wooden doll standing between them shows the relative scale of a small child.

the Warren family of Boston, its original owner was Mrs. Mary Stevens Warren of Roxbury whose eldest son Joseph, born in 1741, was the first to use it. He later became the famous Dr. Joseph Warren who lost his life at the Battle of Bunker Hill in 1775. The chest was eventually enjoyed by his children, and many grandchildren and great-grand-children treasured it through successive generations.

Figure 113 illustrates two bedsteads together with an eight-inch wooden doll to indicate relative size. The red canopy bed at the left, with tapering chamfered posts, is as meticulously proportioned as a full-size counterpart, but the green high-post example at the right is a bit more clumsy despite a nicely shaped headboard and pierced rails. Both items are "of their period" (1800 to 1840), which is an important con-sideration in the study of small antiques, many of which have been made

in comparatively recent years. These bedsteads and the diminutive chest in figure 114 are in the largest category of early children's pieces—those made at home by a loving parent or family friend. Such endearing trifles exhibit various degrees of skill in construction, proportion, and design and were obviously intended to furnish homemade dollhouses, or for use as casual amusement or in imaginative play. This particular chest is carved and painted in eighteenth-century style and bears on the back the initials *H.C.*, identifying Henry Crary of Groton, Connecticut, as the young boy for whom it was made well before 1800. Henry was born about 1780 and, according to his ships' logs, became a sea captain sailing from Maine to South Carolina between 1800 and 1814. In the latter year he left Connecticut and traveled west with a one-horse wagon to settle in New York State.

Wood and metal playthings came in quantity from England before the Revolution when John Mason of Philadelphia imported in the ship *Catherine* on November 1, 1773, "a very large and neat assortment of toys . . ." that included wagons, coaches, musical instruments, and

114. Carved and painted pine chest, H. 3″; L. 4¾″. It was made for Henry Crary (b. c. 1780) of Connecticut. After becoming a ship's captain, Henry left the sea and moved to New York State, carrying this childhood treasure with him.

115. Decorated Hudson Valley cutlery box, with a diminutive companion in unpainted pine, c. 1825. L. 12″ and L. 4½″.

116. Doll-size table and benches, c. 1860. L. 24″. The many grained patterns exhibited on the three pieces suggest their purpose as a fancy painter's samples.

many other varieties.[1] Toys were also arriving from Germany and France by 1829 when the American industry was still in its infancy.[2] These facts should be kept in mind when distinguishing between commercially marketed foreign playthings and individually crafted American miniatures.

In figure 115 appears a full-size cutlery box, circa 1825, from the Hudson River Valley, its blue-green background enlivened by black and yellow tassels and swags. The one beside it is of unpainted pine, properly sized to hold the eating implements of a favorite doll.

A nineteenth-century table and benches are shown in figure 116. Although of doll-size proportions, these unusual pieces may indeed exhibit samples of graining offered by a fancy painter. It is apparent that no less than four different patterns appear on the tabletop, with several others executed on the seats and backs of the benches. Such a set could have been used as a shop or window display, or have been merely a whimsy made for a child.

Two figureheads, the tallest of which measures only five inches in height, present much the same problem (fig. 117). Found in Salem, Massachusetts, they are of cherry wood and are as graceful and well proportioned as the large ship carvings they represent. Were they a figurehead maker's models, trifles for a seaman's child, or just pleasing ornaments—the result of a whittler's leisure-time skill?

One has only to observe the many kinds of miniature dishes to realize that children's pastimes have always played a happy part in American domestic life. Most of the small ceramic sets used in this country were made in England as copies of adult tableware. Some of the rarest are to be found in mid-eighteenth-century English salt-glazed stoneware. On October 26, 1760, the *Boston Gazette* advertised a variety of imported stoneware articles, including baking dishes, patterpans in several sizes, plates, coffeepots, and "large and small toys." A selection of the last-named appears in figure 118, accompanied by a large serving dish to show relative sizes.

The English potter Thomas Whieldon, famous for his colored tortoiseshell glazes during the third quarter of the eighteenth century, produced many doll-size pieces. An entry in his account and memo-

117. Miniature figureheads from Salem, Massachusetts, nineteenth century. H. 4″ and H. 5″. Made from cherry wood by a skillful whittler.

randum book, headed "all Toys," establishes that they were made for sale and not as tradesmen's samples. Enumerated in the list are miniature tea and coffee sets, salts with feet, mustard pots, piggins, and several kinds of dishes and plates. The majority were in tortoiseshell glaze, although redware toys have also been excavated at Whieldon's pot

118. Salt-glazed charger, c. 1740. Diam. 14″. Contrasted with a similar plate measuring only 3″. The other pieces are part of a toy table set.

works in Fenton Vivian.[3] In July 1776, one Joseph Stansbury advertised a sale of the contents of his store opposite Christ Church on Second Street in Philadelphia. Among the many English earthenwares listed were Whieldon-type agate, "colliflower," embossed red china, green and black wares, whistling birds, and children's tea sets.[4] A tortoiseshell teapot, stand, and a miniature embossed red china flowerpot are seen in plate 8.

Most ceramics for youngsters were of durable earthenware. A few special sets, however, were manufactured of porcelain at the Caughley factory, located on the bank of the Severn near the town of Broseley in Shropshire. There blue and white china in the manner of Worcester was obtainable from 1772 to 1799 (fig. 119). Some pieces bore a blue-printed S mark. In the journal of Nancy Shippen of Philadelphia occurs the following letter written by her uncle Arthur Lee from Albany on September 22, 1784: "I have sent Peggy a compleat tea-apparatus for her Baby. Her Doll may now invite her Cousins Doll to tea, & parade her tea-table

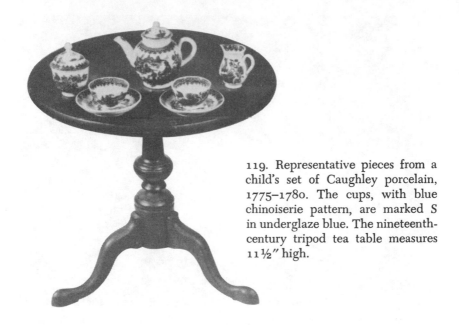

119. Representative pieces from a child's set of Caughley porcelain, 1775–1780. The cups, with blue chinoiserie pattern, are marked S in underglaze blue. The nineteenth-century tripod tea table measures 11½" high.

in form. This must be no small gratification to her. It would be fortunate if happiness were always attainable with equal ease."[5]

Cream-colored earthenware was perfected by Josiah Wedgwood in 1761 and subsequently manufactured by many other English potters. It enjoyed a long period of popularity because the body and glaze were both decorative and durable and were admirably suited to useful as well as to ornamental needs. Proof of its wide use in America is contained in many newspaper advertisements, such as that in the *Boston News Letter* of November 28, 1771: "Several complete Tea-table Sets of children's cream-coloured Toys." Almost twenty years later the *Connecticut Courant*, in January 1790, listed for sale by one Thomas Tisdale of Hartford: "Little Misses French Grey and cream-coloured Tea Sets."[6] The full-size candlestick in figure 120 is impressed *Wedgwood & Co.*, this pottery having been owned by Ralph Wedgwood, a relative of the famous Josiah. Beside it rests a comparable miniature, perhaps made at the Leeds Pottery in Yorkshire. At the upper left are a tiny pepper and

boat-shaped salt from a dinner set. The plates of this set are impressed *Shorthose & Co.*, a mark used by John Shorthose of Hanley, Stafford-shire, during the first quarter of the nineteenth century. In the center a blue-edged platter holds a diminutive joint of meat that must have added a real touch of make-believe to a doll's dinner.

Liverpool jugs of transfer-printed creamware were imported from England in graduated sizes during the early nineteenth century. Some were special-order pieces commissioned for individual owners and prized for their personal associations. Others were utilitarian in purpose. Giant examples measuring fifteen inches in height are occasionally seen and may have been used for advertising display. The largest pitcher in

120. Group of English creamware pieces, late eighteenth century. The candlestick at right is impressed *Wedgwood & Co.* "Childrens cream-coloured toys" were advertised in American newspapers during the last quarter of the eighteenth century.

121. Liverpool pitchers with Masonic and shipbuilding scenes, early nine-teenth century. H. of large jug 15″; smallest 4″.

figure 121 is decorated with seven different Masonic designs. Next to it stands an eight-inch pitcher of medium height decorated with a logging and shipbuilding scene; it exhibits on the reverse a view commemorating the engagement between the *Constellation* and *L'Insurgent* on February 10, 1799. The child-size jug at the left, which is four inches high, also displays Masonic symbols and verse, reminders of what an important part Freemasonry played in English and American lives.

During the first quarter of the nineteenth century many small blue-printed dinner sets were made by several Staffordshire firms. Usually included were soup and gravy tureens, round and oval bowls, covered vegetable dishes, and various sizes of plates and platters that duplicated the large services of the period. Although the majority were decorated with conventionalized flower patterns, some tiny sets exhibit scenic

122. Child's blue-printed dinner service by Josiah Spode, c. 1825. These sets contained scores of dishes, plates, and platters. The soup tureen at top is 3½" long.

designs. The service in figure 122 (of which only a fraction is shown) was made by Josiah Spode and carries his so-called Tower pattern. This view was based on an engraving published in 1798 and entitled *The Bridge Salaro.*

Many American pottery miniatures are found in glazed red earthenware. Some were made in New England, others in Pennsylvania and neighboring states. The eighteen-inch cupboard in figure 123 displays a representative collection of nineteenth-century jugs, jars, dishes, a mold, and a handled cup—all less than three and one-half inches high.

Relatively few early silver miniatures seem to have been made by American craftsmen, compared to those of English origin. Silver toys were precious objects although a few fortunate youngsters were supplied

with tiny teaspoons. The Museum of Fine Arts in Boston owns four miniature American caudle cups and a fork and spoon, all dating between 1660 and 1720.

Other metals such as brass, tin, and pewter are represented by hard-to-date pieces. Some were undoubtedly intended for the young, others were crafted by adults for their own use or pleasure. In the field of illumination, many pewter and glass lighting devices were originally designed with tiny fonts as nursing or "sparking" lamps, and were not counterparts of larger pieces. The little pewter lamp in figure 124, however, is shown with a full-size companion marked by Capen & Molineux of New York City in the late 1840s. This piece with the tin Betty and brass kettle lamps standing beside it are more recent examples of what were termed *trinkets* in the eighteenth century. The little box and canisters at the upper left, painted a warm yellow-brown with sepia

123. Red-painted cupboard. H. 18″. The nineteenth-century American redware pottery includes workmen's off-hand pieces and juvenile playthings.

124. Pewter Capen & Molineux lamp shown with a small whale-oil example, second quarter of the nineteenth century. H. 4¼″ and H. 1¼″. At left are a kettle lamp, and tin Betty lamp with wick pick. The tin box and canisters above were probably imported.

decoration, were probably imported, as was much of the decorated tin used in nineteenth-century America.

Miniatures in blown and pressed glass are both popular and appealing collectibles. The Henry Ford Museum in Dearborn, Michigan, owns a fine collection that includes pitchers, bowls, decanters, lacy dishes, and plates—all made by factories in various states. Many measure less

125. Average-size tumbler and firing glass with miniature counterparts,
c. 1800. The tiny lacy plate must have delighted the heart of a child.

than two and one-half inches in height.[7] Figure 125 presents a cut and
fluted tumbler, from about 1800, with a tiny blown companion, and two
"heavy bottomed wines" or firing glasses, of large and diminutive size.
The lacy plate is not, as might be supposed, a cup plate, its diameter
being only a scant two and one-quarter inches. Although miniature
pieces appear occasionally in books on early American glass, there is
little definitive information concerning their manufacture or use. They
are generally considered to have been "offhand" pieces made as gifts by
individual workmen in their spare time.

126. Three early nineteenth-century table boxes. L. 7½" to 11". The one at left is joined with rose-headed nails and fitted with a small iron padlock. The box at right has wire staple hinges and a covered till—a successful copy of a large blanket chest.

In addition to children's playthings and adult "toys," a third category of objects deserves special mention. This group comprises the small domestic articles that were created for a useful purpose. Certain boxes served multiple needs in the average home and many small table-chests copied large ones and held money, papers, and other valuable possessions (fig. 126). Although some ended their days in the nursery, they were not originally made with this end in mind.

Fireplace cooking demanded many sizes of iron containers for use on the hearth (fig. 127). Straight-sided covered kettles with feet stood in

the coals and ranged from capacious family size to examples measuring only four inches across the top. One of the latter still contains a faded handwritten note that grandmother baked small biscuits in it. Round-bellied pots were found in every household, some so big and heavy that they could hardly be lifted. Others were of very small capacity. Large, spouted kettles hung on the kitchen crane, but small counterparts holding no more than a pint might be found in parlor or chambers to provide hot water when needed. Iron pot lifters with wooden handles were a

127. Pots and pot lifters in a variety of sizes. H. of kettles 10″ and 4″. Small utensils probably hung on short fireplace cranes in parlor or chamber, and those of large capacity were used in the kitchen.

necessity in every home, but small ones to lift little pots are now hard to find, as are, indeed, most early American miniatures.

NOTES

1. Alfred Coxe Prime, comp., *The Arts & Crafts in Philadelphia, Maryland, and South Carolina, 1721–1785, 1786–1800* (Topsfield, Mass.: The Wayside Press for the Walpole Society, 1929, 1932), p. 209.

2. John Demer, "Lewis Page, A Nineteenth-Century New York Toy Dealer," *Antiques* (April 1973), pp. 718–723.

3. Arnold Mountford, "Thomas Whieldon's Manufactory at Fenton Vivian," *English Ceramic Circle*, Transactions, Vol. 8, Part 2 (1972), p. 173.

4. Prime, *op. cit.*, p. 130.

5. Ethel Arms, comp. and ed., *Nancy Shippen Her Journal Book* (Philadelphia and London: J. B. Lippincott Co., 1935), p. 215.

6. Helen Sprackling, *Customs on the Table Top* (Sturbridge, Mass.: Old Sturbridge Village, 1958), p. 7.

7. For further illustrations see Gerald G. Gibson, "The Decorative Arts in Miniature," *Antiques* (December 1955), pp. 516–518.

WOODEN BOXES FOR ALL OCCASIONS

Of all the basic household equipment used from the seventeenth through the nineteenth century, wooden boxes of one sort or another were the most useful and diverse. They vary in size, shape, decoration, and purpose and their construction (whether fashioned by hand or turned out by machine) illustrates the evolution of craftsmanship in the American home.

Frequently made of oak with pine tops and bottoms in the seventeenth century, this combination was eventually supplanted by pine alone, which in turn was augmented by maple, birch, ash, and other local woods. Because boxes and their contents were very personal possessions they often formed a part of a dowry, or were presented as gifts from the bridegroom. When they bear initials and a date, the latter is useful in documenting construction and design.

Carved decoration allied to contemporary furniture predominated in the seventeenth century and carried over into the first quarter of the eighteenth, along with floral and geometric painting of considerable merit. Less sophisticated finishes consisted of various plain colors including shades of red, green, yellow, and blue. During the first half of the nineteenth century graining, stenciling, and freehand painting resulted in some eye-catching effects that could be successfully produced by either professionals or experienced amateurs (plate 9). Remnants of fabrics, contemporary wallpapers, and even newspapers were used for linings and sometimes the first two were used for covering the bare outside wood.

During the seventeenth century the best wearing apparel was not hung in closets, as is the custom today, but was neatly folded and laid away in chests or large boxes to be taken out as needed. These deep

128. New England oak and pine Bible box, incised on lid of till S 1696 F. Found in Vermont. Used for books or for other household storage.

rectangular containers, often referred to nowadays as Bible boxes, were used for many household purposes other than the storage of books. Occasionally they bear inscriptions that commemorate a marriage and the beginning of a new home. Figure 128 presents an oak example with a pine top having period carving and a lidded till incised S 1696 F. In the early eighteenth century storage boxes were sometimes raised on four "ball" feet, others were fitted with a useful drawer and painted with decoration comparable to that found on blanket chests and cases of drawers. The lower chest in figure 129, with its flower and leaf design springing from a central mound, is a recognizable example of which several others with similar decoration are known and believed to have

129. Lift-top box, with drawer, Taunton, Massachusetts, 1725–1730. Robert Crosman, drum and furniture maker, specialized in this kind of vine and bird decoration painted in white, with touches of vermilion, on a dark brown ground. The Bible box beneath, with black, cream, and red floral decoration, is related to other Connecticut examples of the first half of the eighteenth century.

originated in Connecticut. Resting upon it is a so-called Taunton chest, rare in such a small size, attributed with other pieces bearing this distinctive painting to Robert Crosman, drum and furniture maker, who worked in Taunton, Massachusetts, during the late 1720s and early 1730s.

Desk boxes, with sloping lids for writing and interiors fitted with pigeonholes or small drawers, were a convenience in many early households. Originally owned by Captain Abraham Adams of Byfield, Massachusetts, and his wife Ann Longfellow, who were married in 1703, the back of the red-painted box in figure 130 is dated 1721. Arranged above it is a group of slide-top boxes cleverly shaped to resemble books. Beside them lies a pair of small steel-rimmed spectacles next to its original box, dated 1792. This was carved from one piece of wood to fit the spectacles exactly when properly folded.

Many chip-carved household items (so called because the geometric designs were first laid out with a compass and then chipped with a chisel) made their appearance in American homes during the third quarter of the eighteenth century. Frequently designated as "Friesian" in the belief that they originated in Europe, combinations of circles, swastikas, and pinwheels appeared on dated American pieces and utilized the same motifs employed by gravestone cutters as early as the 1720s. The large box in figure 131 is an intricate example of this type of carving and is incised on the reverse: *S.D. 1765*. The rectangular one above it is painted a soft brick-pink, has matching pinwheels on the cover, and was divided into two interior compartments before losing the center partition. It bears the initials of two consecutive owners— *A C 1785* appears on the cover and on one end, whereas *A W 1795* is cut into the bottom. The small upright container at the right is painted a lively green and exhibits eight different carved motifs on its sides and top.

One can only guess at the primary purpose of many boxes that still survive, but a long, narrow, undecorated example bearing the expertly carved date of 1765 carries evidence of its original use by the presence

130. Red-painted desk box dated 1721, from Byfield, Massachusetts. The interior contains three deep drawers. Early wooden boxes in book form are said to have been made to carry prayer books. Incised lettering on one side of the spectacles case reveals that it was made by *E. F. J. for S. J.* on *August 13, 1792.* The spectacles apparently cost 3 shillings. In the painting a Chebacco pinky is nearing completion on the Essex River shore.

therein of three ancient bone-handled razors. This type of receptacle is apparently typical of its period. In the inventory of Colonel Robert Oliver of Dorchester, Massachusetts, "a Shaveing Box and Raisers" was listed at 6 shillings in 1763. Another homemade box used in Oakham, Massachusetts, signed: *W C 1765*, has four square compartments and two narrow partitioned slots, which prove it to have been planned for coins and folded bills.

A different style of chip carving is observable on the box top in figure 132, which was evidently never completed. Its stylized designs of galleons and architectural facades separated by waving palm trees suggest the hand of a sailor imbued with the romance of foreign ports.

131. Three chip-carved boxes of typical eighteenth-century style. The large, unpainted example dates to 1765, the pink-painted one at left to 1785. A curious handle and sliding cover characterize the smallest box.

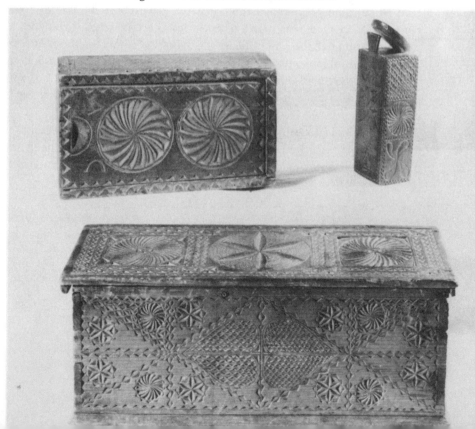

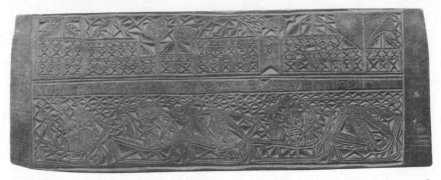

132. Noah Emery's carving, April 8, 1763. Only the maple lid has survived, so perhaps the box was never completed. The design of galleons and palm trees is most effective.

Lettered with painful difficulty across the hard maple of the panel is the legend: APPREL THE 8 YEAR 1763 NOAH EMERY HIS BOEX. One Noah Emery (perhaps this very one) was born in Exeter, New Hampshire, in 1748, was married, and died there in 1817. If, indeed, he did this carving at the age of fifteen, it would account for the naïve yet inherently rhythmic quality of the work. Another item reminiscent of the sea is the handsome nineteenth-century box in figure 133 with putty-color and pinkish-red compass points laid against a black background.

 Chronological dating depends chiefly on inscriptions, decoration, and construction—whether carved, painted, stenciled, or grained, and if hand- or machine-made. The inset bottoms of eighteenth- and early

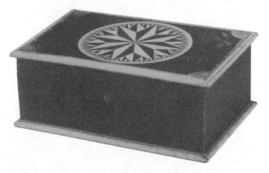

133. Black box with painted decoration in putty-color and red, second quarter of the nineteenth century. The sharply drawn compass points suggest a seafaring background.

134. Two eighteenth-century spice boxes. Large handmade nails and heavy laps represent early work in contrast to the small tacks and lighter construction employed at the end of the century.

nineteenth-century woodenware were usually held in place by small wooden pegs. The lapped points of sides and tops were secured by handmade iron nails, or tacks having irregular shaped heads that have frequently become obscured with rust over the years. The painted box at the left of figure 134 belonged to one Catherine Van Pelt in 1775 and the heavy, well-shaped laps and large nails confirm its early date. The late eighteenth-century box at the right exhibits the small handmade tacks of its period. An early oval container, shown in figure 135, shows scratch carving and bears the date 1747 on the pine cover. Here the nails are large and rose-headed, but the bottom, made of ash, is held only loosely through the pressure exerted by the sides. The small pillbox at upper left has thick, well-formed laps, and handmade nails comparable to those seen on the Van Pelt box, whereas the smaller pill holder at right, included for comparison, illustrates all the characteristics of nineteenth-century machine-made construction.

Deep, triangular boxes to store gentlemen's tricorne hats were an eighteenth-century necessity. A much-used example with its worn cockaded chapeau is seen in figure 136. It is lined in part with a Newport, Rhode Island, playbill dated 1792. Shortly after 1800 high-crowned beaver hats with shaped brims began to come into vogue, and tall round

135. Spice and pillboxes illustrating sequence of construction. The lower container is crudely assembled and exhibits naïve scratch carving on the top that includes the date 1747. Of the two boxes above, the left is skillfully fashioned with conforming laps and handmade tacks. That on the right is a mid-nineteenth-century commercial product composed of thin, poor quality wood that splits easily.

136. Tricorne hatbox from Rhode Island, eighteenth century. The iron ring at lower right was used to hang the box flat against a wall.

or oval boxes—either of wood or pasteboard—were made to accommodate them. Figure 137 illustrates one of the former, the front ornamented with a handsome coat of arms probably executed by a coach painter. In the course of time the pine top split and subsequently was home-repaired by nailing on a piece of strong fabric to hold the broken parts together.

Bandboxes of graduated sizes to transport ladies' bonnets, scarves, flowers, and other accessories became extremely popular during the second quarter of the nineteenth century. Made of pasteboard covered with many different patterns of gaily colored paper, they now provide a delightful glimpse of native flora and fauna; newfound modes of transportation; and designs relating to prominent persons and places—all of which fascinated Americans during the earlier years of the young Republic. The most famous bandbox maker, Miss Hannah Davis of East Jaffrey, New Hampshire, constructed her boxes of spruce and pine, which added greatly to their strength and durability. These she covered with hand-blocked floral papers and lined them neatly with contemporary newspapers saved for her by neighbors and friends. The lining of the cover in figure 137 is dated: *Boston, Oct. 18, 1845.* As a finishing touch she affixed a small printed label to the underside of the lids, giving her name, address, and the words *Warranted Nailed Band Boxes.* Hannah began her business in 1818 at the age of thirty-four, and died in 1863 after a most productive career during which some of her most enthusiastic customers were the girls working in the textile mills along the Merrimack River, to whom she carried her wares in a wagon or sleigh.

The nineteenth century saw a great increase in the use and variety of boxes. Some of them were carefully designed for specific purposes, others appear to have been personal whimsies such as the quaint little pair comprising a small house with ell in figure 138. Hinged covers lift to reveal newspaper-lined receptacles dated: *Portland, Sept. 12, 1837.*

Wooden tea caddies of American make are not as common as imported pieces or those made of metal. The stylish box in figure 139

137. Bandboxes of wood and paper. The competent decoration on the lower one was probably done by a professional coach painter in the eighteenth century. Above is a paper-covered example by Hannah Davis of East Jaffrey, New Hampshire, c. 1845, whose printed label is pasted on inside of the cover.

138. Two pine boxes from Maine combine to form a house with ell, c. 1825. Dovetails and a central chimney add to their attraction. The roofs are hinged to serve as covers.

139. Tea box from New York State. The stylish skirt and rose-red swags suggest an early nineteenth-century date.

140. Heavy, hand-carved construction is visible on the bottom of the tea chest in figure 139.

141. Dome-top box with distinctive freehand decoration, 1800–1810. Similar work of this unidentified itinerant has been recognized on plaster walls in central and southern Massachusetts, Connecticut, Vermont, and New York. The floral designs are freely rendered and are occasionally combined with stylized birds.

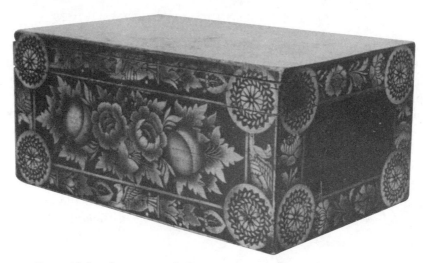

142. Box with handsome stenciled patterns, probably made by Ransom Cook, Saratoga, New York, c. 1825. Stenciling was applied to walls, floors, and household items, including furniture, picture frames, and boxes. Bronze powder was rubbed onto a tacky varnish through the openings cut in an oiled paper stencil. (Historical Society of Early American Decoration, Cooperstown, New York)

probably came from the Hudson River Valley and its splayed feet are an echo of the high-style bureaus of the late Federal period. The Spanish-brown surface is embellished with rose-red swags looped back with black bowknots and tassels, and two moss roses adorn its handsomely molded lid. Unusually heavy hand-chiseled construction appears on the underside of the scalloped base (fig. 140).

Two boxes are shown together in plate 10 to emphasize the wide range of charming ornamentation that abounded in the early nineteenth century, most of which reflected the amateur efforts of owner or maker. Occasionally a box will display the skill of a traveling artist, such as that in figure 141. Recognizable birds and flower sprays, painted in black and white on a buff ground with touches of vermilion, betray the brush of an anonymous decorator whose distinctive freehand designs have been found on plaster walls in a number of old houses in Massachusetts, Connecticut, Vermont, and New York.[1] This discovery proves that he also decorated household accessories. The newspaper lining carries a

probate notice dated: *Windham* [Vermont] *1806,* but it should be stressed that, without supporting evidence, many dates on lining papers indicate only approximate age. Earlier newspapers saved for this purpose were occasionally used, and later ones also, if a box was not lined when first made. In this case, however, handmade tacks and superior construction reinforce the validity of the 1806 date.

Interest in stenciling woodenware, as well as walls and floors, reached a peak about 1825. The box in figure 142 is a fine example, executed with bronze powder applied to a dark ground. Block carving provided a very different surface with an unusual texture and contrasting colors as shown in the box bearing the name *Rebecca E. Lord* (fig. 143).

The big development of the nineteenth century was the proliferation of so-called pantry boxes, which were made in all sizes and shapes

143. Box of Rebecca E. Lord. Block carved and painted in putty-color with blue heart and star decoration, c. 1830. It was probably made as a gift.

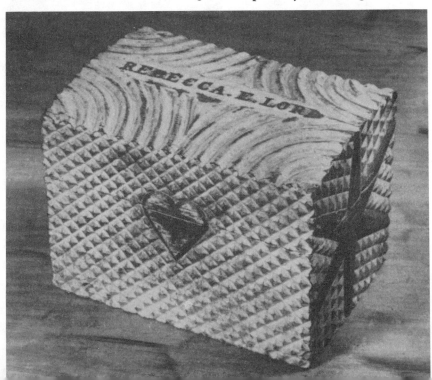

144. Three home-decorated pantry boxes. At left, Mercy Needham's box, dated 1818; at center, one of a set of four graduated containers with owner's initials stenciled in gold on a green ground, c. 1830; at right, a swastika, stars, and a band of sawtooth carving ornament an early nineteenth-century cover.

for almost every household purpose. Large oval containers were favored for herbs; round receptacles accommodated homemade butter and cheese; smaller sizes were for sugar, spices, and small quantities of meal; and tiny specimens, both round and oval, held pills, sealing-wax wafers, and other small oddments. Pantry boxes may be either home- or factory-made, and they exhibit many interesting variations of form and workmanship (fig. 144). The black and red example at the left bears the painted inscription: *Mercy Needham's Box, Smithfield, Sept. 13, 1818.* The box at the right, on which the maker lavished time and care, probably dates to the early years of the nineteenth century. In the center is one of a matching group of graduated spice holders painted bright green with gold-stenciled initials.

The large box in figure 145 supports a set of four small factory-made examples, made after 1850, of which the tops are birch, the sides, maple, and the bottoms, pine. The laps are secured with copper tacks, and a label on the inside cover reads: *Manufactured by Sam'l Hersey, Hersey Street, Hingham, Mass.* The Herseys originally turned out handmade items, but after the middle of the nineteenth century they used steam power to manufacture in large quantities.

The Shakers were justly famous for their brightly colored household boxes, always identifiable by the long, narrow side and cover laps in-

145. Pantry boxes used to contain herbs, sugar, spices, sealing wafers, and pills. The small set of four was factory-made after 1850, one of which bears the label of Samuel Hersey of Hingham, Massachusetts.

variably pointed in the same direction. A representative nineteenth-century group is shown on top of a 1792 bookcase in plate 11.

NOTE

1. Nina Fletcher Little, *American Decorative Wall Painting, 1700–1850*, new enl. ed. (New York: Dutton Paperbacks, 1972), pp. 93–96, 143, 144.

CERAMICS
USED
BY
AMERICAN
HOUSEWIVES

During recent years many pieces of old china have been brought from Europe, both by collectors and by antique dealers buying for an American clientele. Certain types of earthenware, such as delft, salt-glaze, and printed Staffordshire, were used here in quantity during the eighteenth and first half of the nineteenth centuries. The more sophisticated porcelains from France and England, however, are seldom named in documentary sources, and apparently appeared chiefly on the tables of the well-to-do.

Students of American decorative arts, and many others interested in period furnishings, are now seeking to determine exactly what kind of ceramics would have been found in the average American home between 1725 and 1850. Research on this subject may be pursued in sev-

eral fields. The making of utilitarian red pottery was a basic American craft from the seventeenth century to the time of the Civil War, and it is probable that few country families did not own one or more pieces. Dutch and English earthenwares and Chinese porcelain were widely imported during the eighteenth century and were advertised in many newspapers that are still available for study reference. After 1800 tablewares decorated abroad for the American market became extremely popular. Estate papers, such as wills and inventories, sometimes enumerated household china, and specific pieces still turn up bearing written histories of American ownership for many generations. Archaeological digs at private and historic sites often reveal the chronological sequences of items discarded hundreds of years ago.

Although the modest Colonial home relied heavily on wooden and pewter dishes for everyday use, and on utilitarian red pottery for storage and preserving, a surprising quantity of tableware from Holland, England, and China arrived at many American ports during the eighteenth century. That it enjoyed a brisk sale is proved by the numerous vendues advertised in the local press.

Because redware milk pans, pots, and jugs usually belonged on convenient pantry shelves (see fig. 45), the best china was to be found in the front of the house. In 1737 Jacob Williams of Roxbury, Massachusetts, kept china, glass, and earthenware listed at 90 shillings upon a case of drawers in the "Great Chamber." Thomas Fairbanks owned a japanned chest of drawers with steps on the top to display his ceramic treasures. Aaron Davis, a Roxbury, Massachusetts, merchant, stored his china, glass, and crockery in the "closset" of the "First Room" in 1773. But cupboards with shelves let into a side wall, or built across the corner of a room, were preferred locations for storage or display. Referred to as *beaufats, bofats,* or *boofits* in contemporary records, these names were colloquialisms derived from the word *buffet.* In the Georgian period this signified an open cupboard or repository for the silver, china, glass, and cutlery kept therein as ornaments or for use at table. Contrary to twentieth-century practice, the contents were not always arranged in a formal manner. The inventory of one William Burroughs

of New York City is typical of others of the period, and lists as follows
the miscellaneous contents of his corner cupboard in 1754:

2 white marble bowls, & broken china therein
2 large punch bowls, burnt china
3 small blue and white china bowls, old and
 somewhat cracked
2 small deep china plates, cracked, 2 broken
 on the edges
6 old china cups and saucers, old and cracked
Pr. of quart decanters of white flint [glass]
2 old pewter teapots and 2 pint mugs
4 glass bottles with stoppers of white flint

For the purpose of serving tea, which sometimes corresponded to
supper, a mahogany or japanned tripod table was often kept set up in
both farmhouses and city mansions. Trays, called "waiters" or "tea
boards," contained the china "tea furniture" or "tea geer" that frequently
included a teapot, sugar and milk pots, cups, and saucers.[1] A 1743 Salem,
Massachusetts, inventory lists a set of blue and white china on an inlaid
tea table. In Boston in 1734 a japanned tea table held twenty-seven
pieces of china, together with a copper tea boiler and stand. In the late
Federal period, with the increased use of separate space for dining,
room-size pantries with rows of high shelves accommodated the large
dinner sets of Canton, Rose Medallion, blue Staffordshire, and other
imported crockery so popular in American homes during the first half of
the nineteenth century.

Although early newspapers containing notices of ceramic importa-
tions may still be found in town and city libraries, several convenient
compilations of advertisements from specified Boston, New York, Phila-
delphia, Baltimore, and Charleston papers have been published, and are
recommended for easy reference.[2] From the evidence now available, it
appears that during the first half of the eighteenth century English salt-
glazed stoneware, blue and white Chinese porcelain, and delftware from
Holland and England were the ceramics most frequently found in
American cupboards. Tin-enameled earthenware tiles for fireplace fac-

ings, described as square blue and white Dutch tiles, were coming into Boston as early as 1725. On February 6, 1738, a notice in the *Boston Gazette* offered "all sorts of Dutch Tyles viz, Scripture, Diamonds, etc." "Neat Scripture & Landskip" designs were for sale on Cannon's Dock in New York City in 1764. Hand-painted delft tiles were used to embellish American fireplaces throughout the first half of the eighteenth century, but in 1762 something new appeared on the market, described as "red and white, and blue and white English Chimney Tiles." This referred to the newly invented process of transfer printing, when printed instead of painted tiles were first issued by John Sadler of Liverpool between 1758 and 1761.[3] In 1784 John Rawlins of Baltimore advertised in the *Maryland Journal and Baltimore Advertiser:* "a very neat Collection of the very best Liverpool Tile, for Chimney-Pieces. . . ." Figure 146 illustrates three fireplace tiles from eighteenth-century American homes. Other types of delftware besides tiles came to America in quantity from both England and Holland. Bowls of "divers Sizes and Colours," tea sets, mugs, and plates were only a few of the items advertised. Figure 147 shows an English lobed dish and a Bristol bowl. The former is a seventeenth-century form, and by 1876 it had descended through five generations of one American family. The rare English delftware standing salt in figure 148 retains an eighteenth-century history of ownership in one New Hampshire family.

Equally popular in America was white stoneware—a thin, finely potted body covered with a brilliant, slightly pitted salt glaze. By 1724 white stone cups and saucers, bowls, plates, salts, and milk pots were among the articles imported from England and advertised for sale. Salt-glazed tea ware and many incidental pieces (see fig. 118) were favored in Philadelphia up to the time of the Revolution where enameled stoneware was advertised as late as 1773 (fig. 149).

A great deal of Chinese porcelain found its way to the Colonies, carried in English merchant ships during the mid-eighteenth century. *Blue and white China* was the usual designation, although the adjectives *burnt* (highly fired) and *enameled* (painted in colors) were also used. *East-India Ware,* and *Nanking* or *Nanquin* were other descriptive terms

146. Three eighteenth-century tin-enameled tiles from American fireplaces. At left, painted Holland delftware found in Salem, Massachusetts; at center, Liverpool transfer print "Tythe Pig," from the Parson Allen house, Pittsfield, Massachusetts; at right, early example of a marked Liverpool tile by John Sadler, from a Philadelphia house built in 1765.

147. Tin-enameled bowl and dish. The bowl's high foot rim and straight sides indicate an early eighteenth-century date. A lobed dish of a form similar to this example bears a date of 1651. Family history places this piece in America during the last quarter of the seventeenth century.

148. Lambeth delftware standing salt, made in London c. 1650. Descended in a New Hampshire family since before the Revolution.

by which Chinese porcelain was advertised. When the *Empress of China*, the first American ship to trade directly with Canton, returned to New York in 1785, her cargo included Chinese tea and table sets, blue and white and enameled basins and bowls, with two sizes of cups and saucers.

After 1750 several kinds of ceramics reflecting the newest English taste began to appear in American homes. "New fashioned turtle shell

tereens" were featured in 1745. Other tortoiseshell items were imported by the crate. Almost as soon as Thomas Whieldon and his Staffordshire contemporaries had perfected their colored glazes for English buyers, agate, melon, cauliflower, and pineapple patterns were readily obtainable in America. Plate 12 pictures a Georgian bofatt, or corner cupboard, containing glazed earthenware pieces that correspond to the type of shipments advertised in local newspapers during the 1760s and 1770s.

Nottingham mugs of heavy brown stoneware also came into Philadelphia, New York, and Boston in the early 1770s. The smallest example

149. Salt-glazed teapot and molded dish, c. 1760. Enameled stoneware of this type was imported in quantity prior to the Revolution. The dish has an interesting American connection as the bird is said to be a yellow redpoll that was copied from a specimen sent to England by the well-known Pennsylvania botanist John Bartram.

shown in figure 150 is known to have been owned by a family in Ashby, Massachusetts, since at least the 1780s. Delicate red stoneware, some exhibiting Chinese influence, was made in England throughout the eighteenth century and appeared in America soon after 1750. "Red china tea and flowerpots" and "embossed red china" were sold in New York City in the 1770s. "Red Engine lath China teapots" were advertised in Philadelphia in 1771. An engine-driven turning lathe had been installed by Josiah Wedgwood as early as 1765. Black wares were also imported under the names of *Egyptian* and *black agate,* corresponding to what collectors know today as Jackfield and black basalt (fig. 151).

During the last quarter of the eighteenth century cream-colored pottery superseded all earlier importations and eventually drove the old-fashioned delft, salt-glaze, red, and variegated wares off the market. Creamware, covered with a transparent lead glaze, was manufactured by many potters including Josiah Wedgwood who, after securing the patronage of Queen Charlotte about 1765, called his own cream body "Queen's ware." It was equally suited for kitchen or dairy, for enameled

150. Brown Nottingham mugs, mid-eighteenth century. The smallest one, owned in rural Massachusetts since the 1780s, is 2¾" high. Nottingham ware was advertised "both for city and country consumption" in *The New York Journal* on January 2, 1772.

tea and dinner ware, and for mantel ornaments including animals and figurines (fig. 152). Another late-eighteenth century favorite was pearl-ware, made in blue-, green-, wine-, and brown-edge dining sets. Figure 153 shows a sauce tureen with gravy and soup ladles in Wedgwood's blue-edge "Mared" pattern.

Before the Revolution America was not a pottery-making country in the European sense, although suitable clay was available. Local ceramic ventures often failed for lack of financial support, and it was not until the first half of the nineteenth century that the manufacture of commercially designed and produced chinaware was successful in the United States. From the seventeenth to the nineteenth centuries individual potters turned out quantities of everyday pieces that exhibit colorful glazes, gay sgraffito designs, or fanciful decorations in white slip. It was this red earthenware, intended for the storage, preparation, and serving of food, that was used in pantries and farm kitchens all the way from New England to the Carolinas. Plate 13 shows an old kitchen dresser containing a collection of New England pottery of typical forms and glazes.

151. Red lathe-turned milk pot, black basalt teapot, and a black-glazed covered jug. All these wares were to be found in the Colonies before the Revolution.

The making of redware was a prosperous craft in New England by the middle of the seventeenth century. Red clay abounded, the same material being used for the making of bricks. By the mid-eighteenth century a potter's shop, located in part of a barn or a shed, was to be found in almost every sizable New England town. Shaping of hollow ware was dependent on the rapid revolving of a foot-operated "kick" wheel on which lumps of clay were "thrown," to be drawn up by the potter's dexterous hands. Pie plates, platters, and trays were shaped by

152. Creamware group representing the most popular pottery during the last quarter of the eighteenth century. The enameled teapot at left was probably made at the Leeds factory in Yorkshire. The figurine identified as Andromache weeping over the ashes of Hector is attributed to the Staffordshire potter Ralph Wood. The unusual wine measure with mask spout is dated 1783.

153. Blue-edge tureen and ladles in Wedgwood's pearlware. Introduced
c. 1779, the whiteness of the pearl body was enhanced by adding a tiny
amount of cobalt blue to the glaze. Dining sets with colored edges were
offered for sale in America during the 1790s.

hand-pressing thinly rolled disks of half-dried clay against the convex
bottoms of thick redware molds that resembled clumsy heavy dishes.
Pieces of flatware were held apart during baking in the kiln by small
triangular objects called "stilts." Stilt marks (groups of three little rough
spots) may be found on backs of rims of many kinds of early plates.

Lead was the principal ingredient of the clear glaze that character-
ized most pieces of New England manufacture, the glaze being usually
applied to one or both surfaces of a pot or dish. Inadvertent variations
of color occurring in individual examples were often due to impurities
in the body or glaze, whereas unexpected mottling or streaking could
result from irregularities of temperature during firing in a wood-burning
kiln. Differing amounts of certain substances, such as manganese, cobalt,
or verdigris, would produce shades of brown, black, or green. Copper
oxide was the most costly, and few pieces are seen that are wholly
glazed in a true green. Little jugs that are believed to come from south-

154. Pottery-making implements from Pennsylvania include a stilt or cockspur for stacking plates in the kiln, a marzipan mold, and a wooden coggle wheel. The 1840 slip cup at upper right was used at Thomas Haig's Old Pottery in Philadelphia and shows depressions at the sides shaped to accommodate the thumb and three fingers. The lower cup has multiple pouring spouts to produce four parallel lines of slip. The plate mold at bottom is impressed: *John Bell 1857*.

eastern Massachusetts are one exception. An example of this is seen third from the right on the second shelf from the top in plate 13.

Certain potters in the early period enhanced their pieces with wavy lines incised with a sharp pointed tool before glazing. Notched rims on large dishes were produced by a small wooden wheel called a coggle. Slip decoration (made extensively in both Pennsylvania and New England) was applied with earthen slip cups contoured to fit the hand. These odd utensils had one or more perforations fitted with goose quills

through which single, multiple, straight, or wavy lines were trailed across the surface of the body. Figure 154 illustrates a group of pottery-making tools from Pennsylvania, including a plate mold, slip cups, clay stilts, and a primitive wooden coggle. Slip was made of white pipe clay thinned with water to the consistency of heavy cream. Its use for decoration was widespread from the eighteenth century to the time of the Civil War. Large dishes bearing noble sentiments such as "AMERICA," "Temperance Health Wealth," and "Forgive all Injuries" were very popular. So were special-order plates designating favorite types of pie, among them lemon and mince. Concerning the latter, an enthusiastic potter inscribed the endorsement, "A mince pie related with good brandy is one of the best dishes" (top of plate 13).

Other pieces bearing makers' or owners' names occasionally come to light. The two-handled jug in figure 155 has simple slip decoration and the inscription: *Joseph Goodell 1788*. This could be an English piece, but it has a long history of ownership on a farm in central New Hampshire since at least 1800. One Joseph Goodell, born in 1755, died

155. Slip-decorated jug bearing the inscription: *Joseph Goodell 1788*. Used on a central New Hampshire farm before 1800, it may have been made for Joseph Goodell (b. 1755), who died in Warwick, New Hampshire, in 1829. At right is "Aunt Sally" Carter's capacious sugar bowl from the old John Osborn pottery in Boscawen, New Hampshire, c. 1820.

in the adjacent town of Warwick in 1829. His son and grandson lived only a few miles west in the pottery-making town of Orange.

The technique of sgraffito is the exact opposite of slip decoration. In sgraffito the piece is entirely covered with a coating of light-colored clay, the designs then being cut through the top layer to reveal the dark body beneath. This method, resulting in gay and elaborate designs of flowers, animals, and human figures, was extensively practiced by Pennsylvania German potters and also in the south of England from where pieces were imported as early as the seventeenth century for use in the American Colonies.[4]

Because the making of American redware was essentially a folk craft, potters' marks are seldom found. To determine place of origin, the form, glaze, decoration, and family history must all be taken into account and may provide the only clues to the maker and date. An early, unglazed jar in figure 156 carries its own identification, incised when the clay was still soft, reading: *May ye 8 1739 J D hur Jug price 2s 6d Give me to make with your hand and I will fill it if I can.* The jar was

156. Jar dated 1739, made for his wife by John Day of Pownal, Maine. It was passed down to a daughter in each generation for 230 years.

157. Bowl and cider mugs from Orange, New Hampshire, first half of the nineteenth century. The bowl is marked in the glaze: *Hazen of Orange, N.H.* Jesse Hazen was born in Orange and worked there at the local pottery.

traditionally made for his wife by one John Day of Pownal, Maine, and descended to a daughter in each generation for two hundred and thirty years.

The three better-than-average pieces shown in figure 157 illustrate the decorative bands of wavy lines previously mentioned. One mug is finished in lustrous black, the other in a soft green glaze varied with deep yellow mottling. All three pieces were made in Orange, New Hampshire, which lies midway between Bristol and Lebanon. Jesse Hazen (whose father Jeremiah was born in Rowley, Massachusetts, 1778) worked at the local pottery in the early nineteenth century, and traced in brown glaze: *Hazen of Orange, N.H.*, on the surface of the handsome bowl.

The capacious sugar basin previously seen in figure 155 was a product of the Osborn pottery in Boscawen, New Hampshire, and originally belonged to "Aunt Sally" Carter. Aunt Sally was perhaps the sister of Mary Carter who married John Osborn, founder of the Boscawen pottery, in 1816. This receptacle exhibits a very unusual redware shape, being reminiscent of a Neoclassical form found in high-style English decorative arts before the turn of the nineteenth century.

One of the best-known potteries in New England was carried on, between 1791 and 1885, by three generations of the Clark family. It was located in a section of Concord, New Hampshire, later known as Mill-

158. Earthenware plates from the Clark pottery, Concord, New Hampshire. The plate at right is impressed: *Paul Flanders Concord N H Set 10 1843*. At center is an English salt-glazed pattern, c. 1760, that served as inspiration for the later redware design.

ville, near the present site of St. Paul's School. An extremely interesting plate, either a trial or a presentation piece, was made in the mid-nineteenth century when the pottery was owned by John Clark, grandson of the first Daniel. The design is in the manner of a delicate English salt-glazed piece of the 1760s, but the Millville plate is thick and heavy (fig. 158). The finished example at the right, with molded embossed pattern, is incised in script on the unglazed bottom: *Paul Flanders Concord N.H. Set 10 1843*. (Several members of the Flanders family are known to have worked at the pottery during the Clark ownership.) At the left is an identical unmarked plate before glazing. The eighteenth-century salt-glazed example in the middle illustrates the basic source of inspiration for the Millville design.

After the close of hostilities following the Revolutionary War enterprising English potters began to consider decorating earthenware with designs especially calculated to capture the American market. Accordingly, hard feelings between the two countries were soon forgotten in

the pursuit of a lucrative trade. Patriotic subjects connected with the Revolution and the War of 1812 shared popularity with pictures of national heroes, public buildings, and merchant ships. Inspiration for these designs was derived from many sources, including engravings and book illustrations, some of which appeared in both English and American publications. *The Naval Monument,* published by Abel Bowen in Boston in 1816, contained numerous illustrations of naval engagements of the War of 1812 that were soon copied on printed jugs by the Staffordshire firm of Bentley, Wear & Bourne. *The Hudson River Portfolio,* published by H. I. Megarey in New York in 1821, was illustrated with engravings taken from on-the-spot drawings by the Irish artist W. G. Wall. Wall arrived in America in 1819, and his work provided several English potters with some of the finest views found on dark-blue Staffordshire. Two volumes of *American Scenery or Land, Lake and River,* by N. P. Willis, with drawings by William H. Bartlett, were issued by George Virtue in London in 1840. Bartlett's views were used on a number of light-colored pieces of printed Staffordshire ware during the next ten years. Many ship designs, however, were stock patterns; they were sometimes personalized for special-order or presentation pieces by adding the name of a vessel, merchant, or owner.

Late eighteenth- and early nineteenth-century imports for the American market consisted mainly of cream-colored earthenware jugs usually printed in black. Red was occasionally used, and colorful washes were sometimes added by hand. Barrel-shaped pitchers came in all sizes. Most of them originated in Liverpool, with a few produced by the Staffordshire makers, Bentley, Wear & Bourne. Figure 159 illustrates a rare jug, because its satiric design is of American rather than of English origin. James Akin, an early nineteenth-century cartoonist of Newburyport, Massachusetts, had an altercation on the street with Edmund March Blunt, a prominent local citizen now remembered as the author of the *American Coast Pilot.* During the argument Blunt became furious and picking up an iron skillet from a shop door nearby hurled it at young Akin. He, in turn, was so angry and humiliated that he returned home and drew this satirical portrait of Blunt entitling it *Infuriated*

159. Barrel-shape pitchers made in Liverpool for the American trade, first quarter of the nineteenth century. The satirical engraving *Infuriated Despondency, a Droll Scene in Newburyport* (also reproduced on the accompanying jug) was drawn by James Akin of Newburyport, Massachusetts, and taken to England to be printed on earthenware. The special-order pitcher at left is still owned by descendants of Zebedee Cook. His name, with cartouche signifying the Herculaneum Pottery in Liverpool, appears beneath the spout.

Despondency, a Droll Scene in Newburyport. The caricature was sent by sailing ship to Liverpool to be reproduced on pitchers and "vessels of less repute." When this cargo of earthenware arrived back in Newbury-port, some of Blunt's friends sneaked on board the vessel and attempted to destroy every piece. Only two examples are now known to have survived, one in the collection of the Peabody Museum of Salem and the jug here pictured. Akin's droll engraving was also used locally on paper-covered spelling books, one of which is shown above the jug.

The jug on the left in figure 159, which is still owned by the great-

160. Transfer-printed plate carrying one of the many Washington memorial designs that were exported to America soon after his death in 1799.

great-grandson of the merchant for whom it was brought back shortly after 1800, also comes from Newburyport. It is inscribed on the front with the name *Zebedee Cook* and is typical of special-order pieces of this period. The map of the United States, flanked by George Washington, Benjamin Franklin, and other patriotic symbols, is an early design, having also been used on a punch bowl presented to the East India Marine Society of Salem, Mass., in 1801. Numerous designs relating to Washington naturally appeared on Liverpool pottery, some of which were issued shortly after his death in 1799 to serve as memorial pieces. The plate in figure 160 combines many symbolic emblems, including a merchant ship, an American eagle with shield, the figure of Liberty

161. Dark-blue Staffordshire plate, *Mitchell & Freeman/China & Glass Warehouse/Chatham St Boston*. The view of their premises was made for these importers by William Adams of Tunstall, England, between 1827 and 1831. Shipping on Boston's waterfront may be seen in the distance.

holding a laurel wreath, and an obelisk displaying a Washington profile surmounting the words: "Sacred to the Memory of Washington."

Although Liverpool designs tended to be patriotic in concept, glorifying American statesmen, heroes, and commerce, their popularity began to wane by 1820, and their place was taken by dark-blue printed earthenware, whose patterns also flattered American buyers. Printed Staffordshire had reached American ports during the last decade of the eighteenth century and was well advertised in the local press, but it was not then decorated with the American views that were to arrive in such profusion during the 1820s. American historical views were made by at least ten well-known English firms, and this pictorial pottery found its way into many country homes at the same time that city dwellers were using Chinese export porcelain.

Unlike Liverpool, blue Staffordshire came in tea sets and large dinner services. In 1816 the *Connecticut Courant* carried the following notice: "Per ship Asia from Liverpool a large and elegant assortment of Crockery Ware . . . Blue printed Dining Sets (146 pieces, new patterns)."[5] Sometimes different scenes appeared on plates, platters, serving dishes, and other pieces, and each potter used a distinctive border to surround his central views. Innumerable series were produced that included American cities and scenery, public buildings, portrait medallions, arms of the States, churches, steamboats, and patriots' tombs. One such series entitled "Beauties of America" almost exclusively depicted hospitals, asylums, and penitentiaries.

Much historical Staffordshire was sold by china and glass merchants such as Mitchell & Freeman, a picture of whose warehouse on Chatham Street, Boston, appears on plates made by William Adams of Tunstall, England, for this firm between 1827 and 1831 (fig. 161). Unfortunately the majority of newspaper advertisements did not enumerate the names of the Staffordshire firms or the titles of the views imported. Occasionally, however, a merchant did have his name incised on the bottoms of the pieces he sold. Two different series, both issued by Enoch Wood & Sons, Burslem, England, are known bearing the name of the dealer, *Peter Morton Hartford*, impressed on the reverse. From 1823 to 1831

162. Blue Staffordshire tableware imported by Peter Morton, Hartford, Connecticut, between 1823 and 1831. At left is a view of Wadsworth Tower, near Hartford. At right, a toddy plate with harbor view. Both made by Enoch Wood & Sons, Burslem, England.

Peter Morton, listed as an earthenware and glass dealer at 68 Front Street, advertised in the Hartford papers, before moving to New York between 1831 and 1833.[6] One of his notices in the *Connecticut Courant* of June 26, 1826, reads: "100 crates of earthen Ware, have just been received per ship Isaac Hawks, via Liverpool, direct from the manufactory at Staffordshire among which is an entirely new and most beautiful pattern of Tea Ware, called Wadsworth Tower. . . ."[7] Two marked Morton pieces with Wood's seashell border present views of Wadsworth Tower, Hartford, and an unidentified marine subject (fig. 162). A second series imported by Morton consisted of French scenes, with a fruit and flower border, including Lafayette's home, La Grange. This fact made the series of special interest to Americans at the time of Lafayette's second visit to the United States in 1824.

English firms were not alone in creating designs intended to flatter the pride of the young Republic. Although Chinese tablewares had

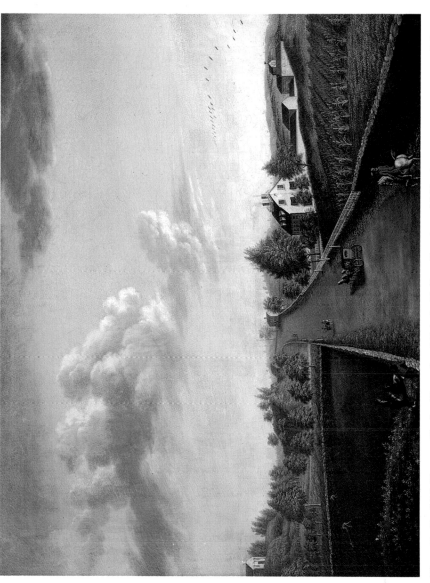

Plate 1. *Ezekiel Hersey Derby Farm* by Michele Felice Cornè, c. 1803. A country estate near Salem, Massachusetts, with garden house at left. Samuel McIntire, the architect, with plans in hand, and Cornè, holding his drawing board, are shown in left foreground.

Plate 2. Grain-painted chest and decorative carvings, c. 1800. At right a pineapple garden ornament with traces of original polychrome paint. The plaque of Washington is attributed to Samuel McIntire. On the wall above, profiles in pine flank a Rhode Island sign painter's panel.

Plate 3. (OPPOSITE TOP) *View of St. Joseph's Near Emmitsburg, Maryland,* by Anna May Motter, 1825. An expert combination of needlework and watercolor. Two Motter girls were students here during the early 1820s.

Plate 4. (OPPOSITE BOTTOM) *Arrangement of Fruit in a Basket,* c. 1830. Still lifes in oil on wood are seen less often than those on paper or velvet.

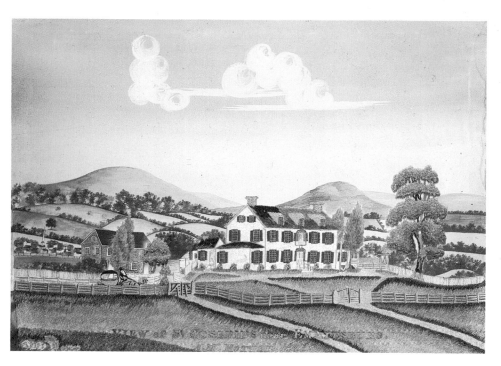

VIEW of ST JOSEPH'S near EMMITSBURG

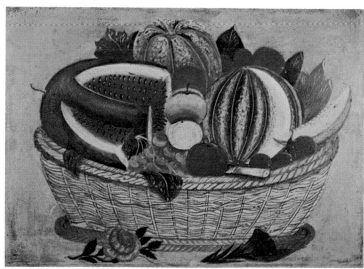

Plate 5. Three types of frames from the second quarter of the nineteenth century: left, black mottling on a yellow ground; center, inlaid and painted hearts on a red background; right, frame touched with color to complement the lady's dress.

Plate 6. Fireboard: *Minot's Light.* This lighthouse was built on a ledge off the Massachusetts coast in 1860 to replace an earlier beacon that was swept away in 1851. The simulated carved and gilt frame is painted on the canvas.

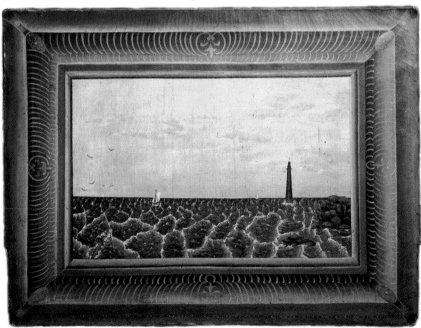

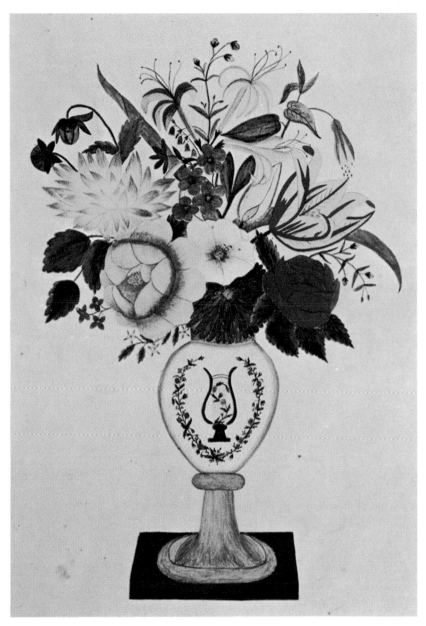

Plate 7. *Vase of Flowers*, 1825–1840. Probably a schoolgirl watercolor, this painting is nevertheless typical of many informal arrangements to be found in nineteenth-century parlors.

Plate 8. An "embossed red china" toy flowerpot and saucer, H. 2½″, stands at left, c. 1785. At right is a tiny teapot and stand, H. 4″, in tortoiseshell glaze such as those entered in the account book of Thomas Whieldon, third quarter of the eighteenth century. The 9″ plate in center is impressed *Spode*.

Plate 9. Storage box with colorful graining, first quarter of the nineteenth century. Small dome-top chests of this character are found with many types of painted decoration.

Plate 10. Ornamented boxes of original design, c. 1825. The lower one has carved and painted decoration, the reverse side being much faded by years of exposure to the sun.

Plate 11. Gaily painted boxes piled on the top of a 1792 New Hampshire bookcase. Many are of Shaker origin, recognizable by tapered laps on box and cover pointing in the same direction.

Plate 12. (OPPOSITE) Corner cupboard containing glazed earthenwares popular in America during the 1760s. At left and right are pineapple and cauliflower patterns; at center, a figurine (one of a set of Four Seasons) representing Winter. The other pieces display various types of tortoiseshell glaze.

Plate 13. A representative collection of redware from various New England potteries, eighteenth and nineteenth centuries.

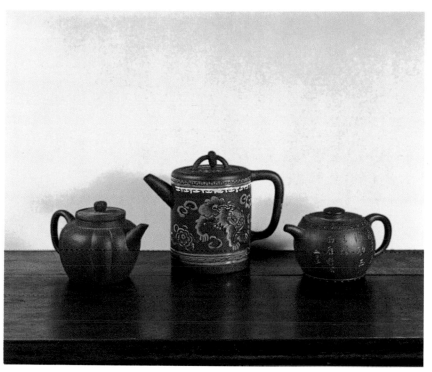

Plate 14. Chinese red stoneware pieces brought home as curiosities through the China trade. These pots came to Annisquam, Massachusetts, in the ships of Captain Oliver Lane, c. 1840.

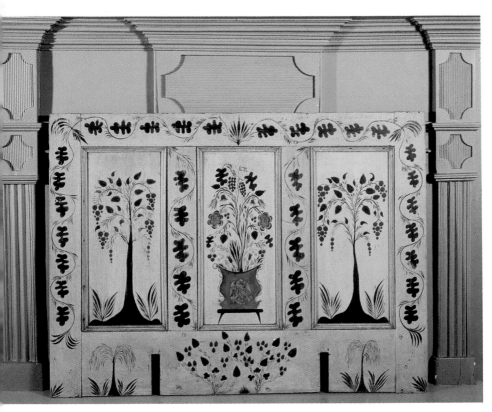

Plate 15. Fireboard from a house built in Southbury, Connecticut, c. 1820. Graceful designs placed in recessed panels, and a handsome eagle superimposed on the blue urn, are noteworthy elements of this decoration.

Plate 16. Fireboard with slats for ventilation, early nineteenth century. The niches, shells, and upper louver bars are all in "deception painting."

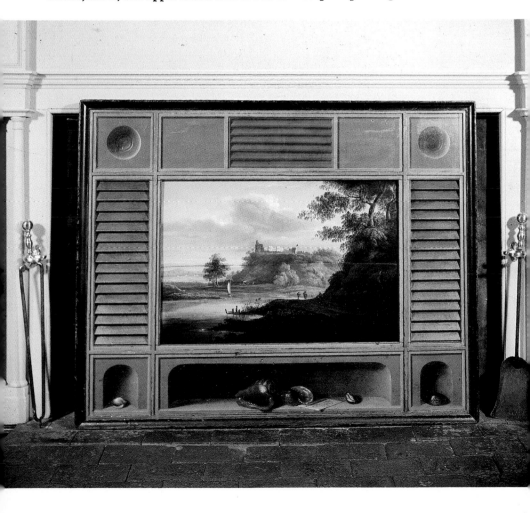

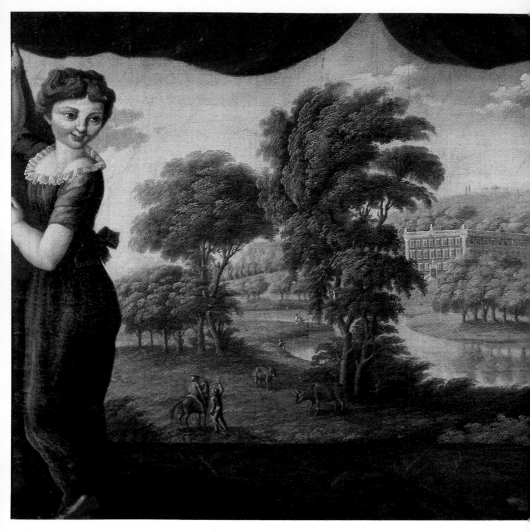

Plate 17. Fireboard from Salem, Massachusetts, by Michele Felice Cornè, 1800–1810. The subject is a view, based on an engraving, of the English country estate Chatsworth in Derbyshire. A few changes in the original design are apparent in the foreground.

Plate 18. Two widths of old striped carpeting, early nineteenth century. Made of home-dyed wool, they exhibit richness of color and irregularities in weaving that are not present in factory-produced fabrics.

Plate 19. Yarn-sewn rug from Maine, early nineteenth century. Striking geometric designs are enhanced by the clear blue, yellow, and deep brown of the vegetable dyes.

Plate 20. Shirred rug of tightly folded woolen strips, c. 1850. The flowering vine reveals considerable artistic skill on the part of the maker.

reached our ports for many years through the East India Company, no Chinese porcelain had been imported directly in American ships until this company's monopoly ceased following the Revolutionary War. Thereafter, designs of American significance were carefully executed in Canton and brought in on almost every vessel that returned after 1784. Chinese patterns, unlike the blue-printed wares from England, were hand-painted in colors sometimes touched with gold, on a gray-white porcelain body, and could be found in nearly every family that included a relative in the China trade. Although impressive special-order items were brought back for public and private entertaining, many ship designs, like those on Liverpool ware, were stock patterns embellished with large American flags. Floral or swag patterns were personalized by adding crests, monograms, or the initials of the prospective owners.

163. Modest examples of Chinese export porcelain brought back in American ships during the first quarter of the nineteenth century. Two teacups at left bear the initials of the Blanchard family of Medford, Massachusetts. At center is a caddy with initials and painted landscape over a bowl painted with the arms of the State of New York. At right is a Masonic cup and a spoon tray with American eagle.

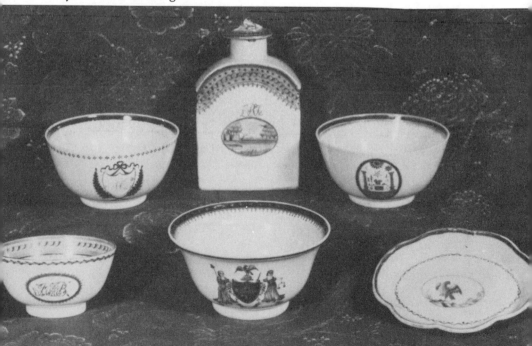

Eagles and Masonic symbols were also commissioned from enamelers at Canton, and pieces with star borders and delicate landscapes were favorites of American captains and foreign agents in the first quarter of the nineteenth century (fig. 163). Other Chinese ceramics, less well known than the famous export porcelain, found their way into many American homes. Made of unglazed red stoneware called Yi-Hsing, these expertly fashioned pots were valued in China from ancient times and were still being produced in traditional styles well into the nineteenth century. The three typical examples seen in plate 14 were brought home to Annisquam, Massachusetts, around 1840 by Captain Oliver Lane, where they remained until the family home was sold during the 1960s.

After 1835 the demand for American patriotic china gradually diminished, although these decorative old pieces have never lost their appeal. Some valuable examples preserve the only remaining pictorial evidence of local events or scenes, and all illustrate the most popular tablewares used in the average home during the first fifty years of American independence.

NOTES

1. Abbott Lowell Cummings, ed., *Rural Household Inventories* (Boston: Society for the Preservation of New England Antiquities, 1964). This valuable publication lists the contents of country homes in the small towns of Suffolk County, Massachusetts, between 1675 and 1775.

2. George Francis Dow, *The Arts & Crafts in New England, 1704–1775* (Topsfield, Mass.: The Wayside Press, 1927); Rita Susswein Gottesman, *The Arts and Crafts in New York, 1726–1776, 1777–1799* (New York: The New-York Historical Society, 1938, 1954); Alfred Coxe Prime, *The Arts & Crafts in Philadelphia, Maryland, and South Carolina, 1721–1785, 1786–1800* (Topsfield, Mass.: The Wayside Press for the Walpole Society, 1929, 1932).

3. Anthony Ray, "Liverpool Printed Tiles," *English Ceramic Circle*, Transactions, Vol. 9, Part 1 (1973), pp. 40, 41.

4. C. Malcolm Watkins, *North Devon Pottery and its Exportation to America in the 17th Century,* United States National Museum Bulletin 225 (Washington, D.C.: Smithsonian Press, 1960).

5. Helen Sprackling, *Customs on the Table Top* (Sturbridge, Mass.: Old Sturbridge Village, 1958), p. 9.

6. Ellouise Baker Larsen, *American Historical Views on Staffordshire China,* new rev. and enl. ed. (Garden City, N.Y.: Doubleday and Co., Inc., 1950), p. 30.

7. Sprackling, *op. cit.,* p. 10.

FIREBOARDS
ON
THE HEARTH

The term *chimney board* was used in eighteenth-century America to designate the decorative wooden coverings intended to close fireplaces in the summer or when not in daily use. Fire fronts originated in Europe where chimney boards were considered to be an integral part of room decoration, and were often painted by well-known artists on order from wealthy patrons. Still-life subjects were popular in the apartments of French royalty, while handsome examples in classical style were designed to complement Robert Adam's decorative schemes in several great estates such as Osterley Park and Audley End. Sometimes pasting cutout prints of colored vases or antique figures on chimney boards provided leisure work for English ladies when visiting their fashionable friends.

In America the designation chimney board was superseded by the term *fireboard* during the early nineteenth century. The majority of examples found in the States are not so sophisticated as those recorded in England, many having been found in farmhouses or modest dwellings in small country towns.

Although fireboards were expected to fit snugly within the outer edge of the fireplace opening, they were also held upright by various other means, such as a wide bottom molding that acted as a support; a turn button that caught the top against the wooden fireplace surround; or two slots cut in the lower section that allowed the andirons to project and rest against the face of the board. They were constructed in one of several ways, the simplest of which consisted of wide boards, either vertical or horizontal, held together with heavy battens on the reverse, the decoration being painted directly on the bare wooden surface. In less primitive examples canvas was stretched across the face and nailed over the edges providing a smooth base for the painted decoration. Other fireboards were covered with imported wallpapers of either scenic or floral patterns and mounted on canvas or wood. Very colorful designs were also obtained by combining cutout paper motifs and applying them in the manner of découpage.

Wooden fireboards were resistant to chimney moisture and soot, but they were heavy to move and awkward to store when not in use. Paper examples mounted on canvas were conveniently light in weight, but they were subject to penetration by rain with resultant disfiguring water stains. Both types were sometimes constructed at home and completed by a member of the household. More often, however, the wooden boards were decorated by a local artisan, such as William Kidd, upholsterer, who advertised in the *Virginia Gazette* in 1769 that he was prepared to hang rooms in paper or damask, do house painting, gilding, glazing, and paint floorcloths, chimney boards, and signs. At other times they were ornamented by traveling decorators, either as separate entities or to conform with the walls and floor.

Flower arrangements in pots or urns seem to have been a most

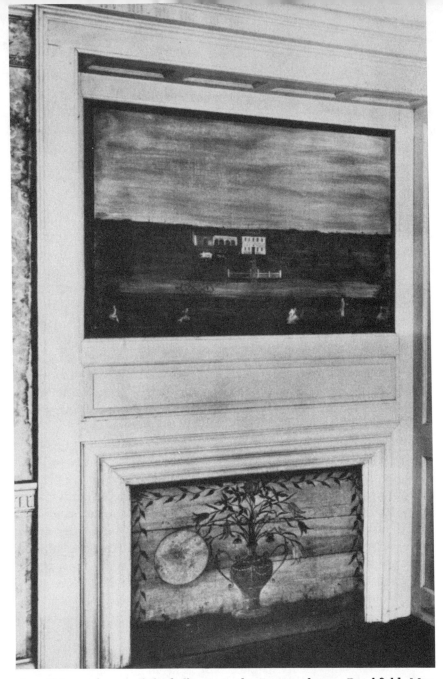

164. Chimney breast of the ballroom in the Banister house, Brookfield, Massachusetts, second half of the eighteenth century. The painted vine surrounding the fireboard was originally repeated on the paneled woodwork. The overmantel picture shows an approximation of the house itself.

popular motif and fireboards with floral centers are found in many different styles. The idea of depicting a container of flowers on the hearth probably derived from the Old World custom of placing jars of greenery within an unused fireplace.

In figure 164 a fireboard with floral composition may be seen still in its original position in a country Georgian mansion in Brookfield, Massachusetts. It fits tightly within the heavy bolection molding of the fireplace for which it was made. The round hole at the left was cut later to accommodate the pipe of a parlor stove. Above is painted a view of the house itself with amusing outsize animals and a stylishly fenced front yard.

One of the earliest and most descriptive references to American fireboards is set forth in the Letter Book of John Custis of Williamsburg, Virginia, who, in 1723, wrote in part:

> Get me two pieces of as good painting as you can procure. It is to put in ye summer before my chimneys to hide ye fire place. Let them bee some good flowers in potts of various kinds and whatever fancy else you think fitt. . . . I send this early that the painter may have time to do them well and the colors time to dry. . . . I had much rather have none than have daubing.[1]

A colorful pot of mixed flowers with an unusually decorative border and grain-painted wooden surround is illustrated in figure 165. Another particularly charming example, circa 1820, from Southbury, Connecticut, appears in plate 15. The freehand design is arranged within three molded panels, the blue pot in the center being enhanced by a gilded eagle montage. In figure 166, a more sophisticated fireboard, circa 1840, exhibits trompe-l'oeil moldings in the nineteenth-century Gothic taste enclosing a graceful arrangement of fruit resting on a traditional marble base. This high-style composition calls to mind a prim early Victorian parlor.

Some homeowners evidently favored fireboards that suggested the interior of an actual fireplace. To accomplish this certain painters simulated facings of tiles, echoing those imported from England and Holland

165. Pot of flowers silhouetted against a dark ocher oval, c. 1825. The enframement of the oval is speckled in yellow ocher on a dark blue or black ground. (Old Sturbridge Village)

during the second half of the eighteenth century. Oddly enough, in the first quarter of the nineteenth century, such borders did not imitate traditional tile designs but emerged as naïve versions of houses, trees, and figures set off in square or circular frames. Figure 167, circa 1830, shows one of a series of fireboards by an unidentified but recognizable hand, all of which betray several characteristics in common. The jug of leafy branches within the curiously shaded fireplace opening and the wide band of stylized trees are unmistakable elements of a single itinerant's work. This particular example is constructed with andiron slots, and the small drop handle at the top center turns a catch that slips under the horizontal boarding and keeps the board from tipping forward. A second artist who worked in central New England accomplished an even more precise imitation of an empty fireplace. The clever perspective of figure 168 with its painted brickwork, andirons, and fire tools belies the

166. High-style fireboard in early Victorian Gothic taste, c. 1840. The frame and corner pieces are trompe-l'oeil simulations of wooden moldings. (Childs Gallery, Boston)

fact that one is really observing a fireboard fitted inside its original wooden frame. This one came from the Daniel Whitmore house in North Sunderland, Massachusetts, the interlaced carved design beneath the mantel having been copied from Plate 47 of William Pain's *The Practical Builder* (London, 1789). A very similar board attributed to the same artist is preserved in Memorial Hall, Old Deerfield, Massachusetts.

Many fancy painters learned the rudiments of their trade from illustrated instruction books imported from England for the edification of American professionals and amateurs. Nathaniel Whittock's *The Decorative Painters' and Glaziers' Guide* (London, 1828) includes a chapter on "The Elements of Ornament" that contains detailed directions for "painting subjects the proper size for chimney boards . . . Flowers, fruits and landscapes, when the painter has acquired the art of pro-

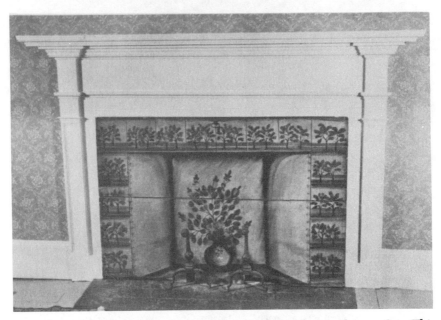

167. Deception-painted fireplace with boughpot and facing tiles, c. 1830. This fireboard is one of several similar examples painted by the same artist who seems to have traveled widely in New England and elsewhere.

ducing them, are beautiful subjects for fire boards, and will be sure to find purchasers at a good price."[2] Landscapes, townscapes, individual houses, and occasional marine scenes are perhaps the most fascinating and varied fireboard subjects, since no two seem to be exactly alike.

In this general category one discovers that local artists derived inspiration from contemporary engravings, many of which were widely advertised as English importations. The picturesque scene in figure 169, dated 1790, with pensive lady and grazing sheep, is obviously not taken from real life but echoes the romantic mood of the late eighteenth century. A view of New York, on the other hand, is definitely copied from the well-known Howdell-Canot engraving entitled *A Southwest View of the City of New York in North America* (fig. 170). First issued in London in 1768, it was reissued in a smaller size by Carrington Bowles in London in 1790, at which time the three men seen in the middle distance

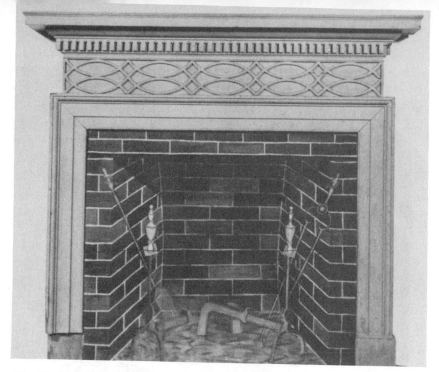

168. Fireboard from North Sunderland, Massachusetts, c. 1825. Brass-topped andirons and fire tools add a realistic touch to the cleverly painted fireplace opening. The carving beneath the mantel was copied from a plate in a 1789 English builder's guide. (Society for the Preservation of New England Antiquities)

were added to the original composition. The prospect was taken from Brooklyn with the Rutgers family brewhouse in the foreground. In the distance Trinity Church is at the extreme right, with the steeple of the New or Middle Dutch Church further to its left. The view is banded with a painted gold frame, slightly tipped to give the visual impression of a picture resting unevenly on the hearth. Other fireboards also exhibit effective trompe-l'oeil enframements, notably the handsome view of Mount Vernon previously shown in figure 99. A green marbleized strip below, with two narrow slots, very possibly was designed to carry through the baseboard of the room for which the fireboard was originally designed. This framed scene resting on andirons must have produced a remarkably realistic effect.

A stylish fireboard from the Philadelphia area presents "deception painting" of unusual quality and appears to date from the early years of

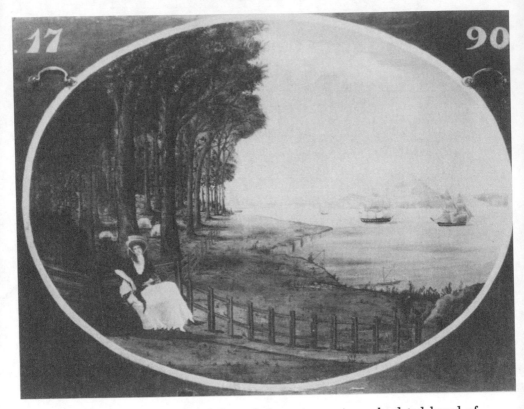

169. Romantic scene with lady and sheep, 1790. An early dated board of unusually large proportions, it was fitted with brass handles to facilitate moving it about.

the nineteenth century (plate 16). The "recessed" niches with shell motifs are skillfully rendered in trompe l'oeil, as are the green louver bars at top. The sides, however, incorporate genuine slatted panels— seemingly a device to provide ventilation. The landscape view is of the English school, much admired in American society of the time, and the board is said to have come from a house where other woodwork was painted in corresponding fashion.

At least two known artists, resident in Salem, Massachusetts, before

1800, painted fireboards for the homes of well-to-do merchants engaged in foreign trade. Foremost among the great shipping families were the Derbys whose vessel *Mount Vernon* brought Michele Felice Cornè from Italy to Salem in 1799. Cornè came directly from Naples, where he had evidently gained experience as an ornamental painter. During his ten years in Salem he executed competent portraits, ship pictures, over-mantel panels, wall frescoes, and colorful fireboards—all of which were extremely decorative in character. Like other artists he used engravings

170. View of the City of New York, late eighteenth century. Taken from Brooklyn with the Rutgers family brewhouse in the foreground. The gilt frame is part of the painting.

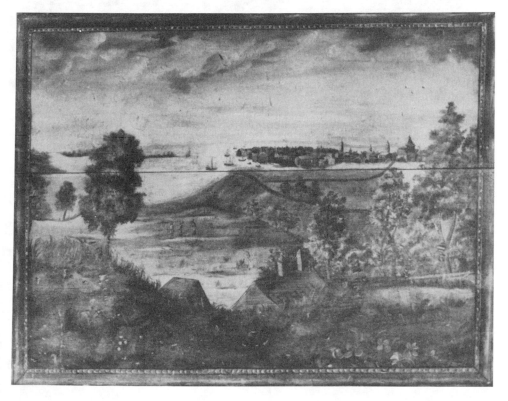

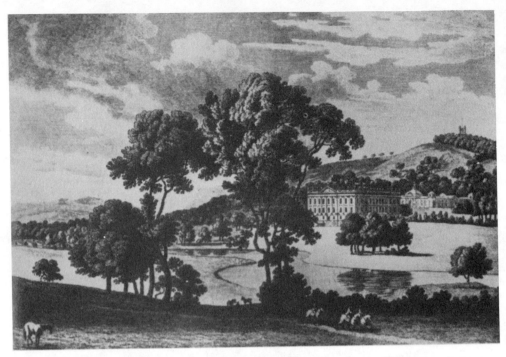

171. Chatsworth in the second half of the eighteenth century. This engraving served as the model for the fireboard in plate 17. It is illustrated as plate 390 in Francis Thompson's *History of Chatsworth* (1949).

as bases for his scenes and one fireboard made for a Salem home bore a view of Chiswick Gardens. This derived from an illustration in the book *A New Display of the Beauties of England* (London, 1776), which was obviously available in America. Another picturesque example by Cornè depicts two children holding draped curtains in the manner of stage lambrequins, thereby revealing a distant view of the English country estate of Chatsworth (plate 17). This landscape is copied directly (with a few minor changes) from an eighteenth-century engraving after an oil painting by the English artist Paul Sandby (fig. 171).

Even earlier than Cornè was the Scottish-born artist Robert Cowan

who arrived in Salem prior to 1782. Cowan also worked for the Derby family, and among other commissions he billed John Derby for a landscape on a fireboard in the amount of 1 pound, 9 shillings, and 7 pence on December 7, 1791.[3] A delightfully ingenuous fireboard scene, possibly from a fireplace in the Andrew Safford house, Salem, could be an example of Cowan's work (fig. 172). Apparently a view painted from Ledge Hill in North Salem between 1798 and 1839, the topography can be recognized today. The North River at right flows into Beverly Harbor after passing beneath a long wooden bridge, with the town of Beverly visible beyond. Bridge Street, now a densely built-up thoroughfare, parallels the far bank of the river, and the lighthouses on Bakers Island loom in the distance.

Probably the only contemporary representation of the 1810 Lynn

172. View from North Salem, Massachusetts, first quarter of the nineteenth century. The North River with Bridge Street at its right, the wooden bridge from Salem to Beverly opened in 1788, and the town of Beverly in the far distance, are all recognizable landmarks today. (Essex Institute)

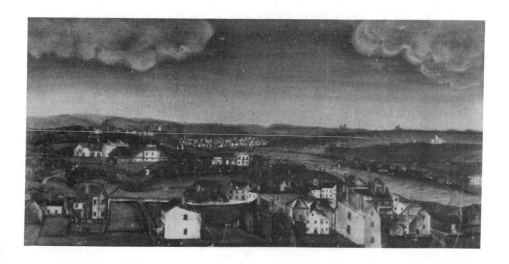

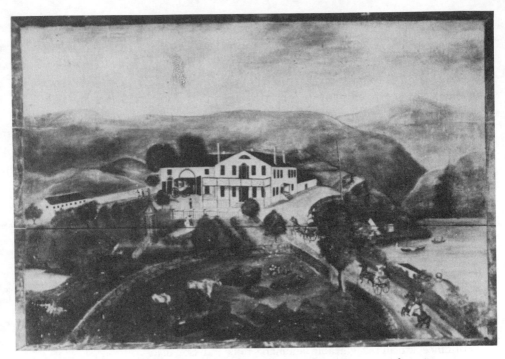

173. Mineral Spring Hotel, Lynn, Massachusetts. This inn was a favorite summer resort built in 1810. It was sold in 1847 to become a private estate and today is the site of a built-up residential area. (Lynn Historical Society)

Mineral Spring Hotel appears on the fireboard in figure 173. This secluded spot was long a favorite summer resort, located on the western bank of Spring Pond in Lynn, Massachusetts, on the margin of which a spring provided healthful water impregnated with iron and sulfur. Much activity is shown by the artist: a coach stands ready behind the inn, several fashionable rigs mount the hill, and two guests approach the summerhouse, presumably to enjoy the view. There was fishing in the pond, shooting in the woods, and beautiful carriage drives in every direction, but in 1847 the property was sold to Richard S. Fay who improved it for a country residence. In later years a locally famous floating

bridge traversed the pond. Now all the rural features have disappeared and the once sylvan retreat has become a closely built-up residential area.

By the first quarter of the nineteenth century the safety of fireboard usage was being publicly questioned through a "communication" printed in the *Connecticut Courant* in 1825. Fireboards placed in unused fireplaces had been reported to be responsible for several fires in New Haven and Hartford, caused by soot, spider webs, or blowing leaves that collected unseen behind them. This inflammable material, it was believed, had been ignited by sparks descending the chimney from another fireplace flue. With the advent of wood-burning stoves during the middle of the nineteenth century many old-time fireplaces were permanently closed, generally with brick facings, thus the usefulness of the movable fireboard gradually ended.

NOTES

1. The Custis Letter Book is deposited in the Library of Congress, Washington, D.C.

2. Nathaniel Whittock, *The Decorative Painters' and Glaziers' Guide* (London: George Virtue, 1828), pp. 135, 137.

3. Derby Family Manuscripts, XXXI, p. 47. Essex Institute, Salem, Massachusetts.

RUGS AND CARPETS – IMPORTED AND HOMEMADE

The earliest floor coverings in America appear to have been the "Turkey carpets" that were imported by the Colonies and used quite widely in wealthy homes after the first quarter of the eighteenth century. During the seventeenth century a few of these prized European textiles were brought across the Atlantic as household goods, but they were primarily used as table coverings rather than being placed on the floor. The modern term *rug* then denoted a warm, handworked coverlet for a bed and was not intended to be used underfoot. Not all the Turkey carpets mentioned in references of the time actually came from the Far East. Many, after 1750, were creations of English and French artisans who worked in the Oriental knotted technique to produce Turkish designs, which were referred to as "rich beautiful *Turkey fashion*" carpets when

imported into Boston as early as 1757. The portrait of Jeremiah Lee, painted in 1769, shows a Turkey carpet on the floor (fig. 174).

English carpets woven with Turkish or Persian patterns were only one of several kinds of floor coverings exported to America well before 1800. The looms were operated by hand or foot, sometimes augmented by waterpower. British carpeting was sold under five different trade names, but only three basic weaving techniques were used. *Wilton* and *Brussels* both imply a wire-formed pile composed of cut or uncut loops; at *Axminster* hand-knotting was produced in the Oriental manner; *Kidderminster* employed a flat, reversible weave also referred to as *Scotch ingrain* that proved the most popular in middle-class parlors until the end of the nineteenth century. This flat, two-ply weave produced a sort of double textile that consisted of two webs or piles exhibiting neither surface loops nor tufted pile as did Wilton and Brussels. Two-ply denotes two sets of colored weft (or crosswise yarns) interchanged on the loom so that the pattern is alike on both sides of the finished fabric, although the colors are reversed in the manner of the so-called night-and-day bed coverlets.

Information concerning the types and uses of foreign imports has been chiefly gleaned from diaries, estate papers, or newspaper accounts of sales and vendues. Unfortunately, few examples used in specific American homes before 1800 are now known to exist, so documentation of patterns and colors has necessarily been derived from the occasional paintings and prints that depict eighteenth- and early nineteenth-century interiors, such as this carpet by Ralph Earl (fig. 175).

Imported carpeting was to be found in many homes prior to 1800, but the great American carpet industry did not get under way until several protective tariffs were imposed on foreign imports in the 1820s. These laws substantially increased the tax per yard on British textiles, making American manufacture economically possible, and resulting in the gradual establishment of many small mills in Massachusetts and elsewhere. The industry was revolutionized after 1839 by the invention of a steam-operated loom to weave patterned ingrains. From this time on domestic carpets became easily available to the modest homeowner.

174. Mr. Jeremiah Lee, Marblehead, Massachusetts, by John Single-
ton Copley, 1769. By the third quarter of the eighteenth century Tur-
key carpets had moved from the tabletop to the floor. (Wadsworth
Atheneum, Hartford)

175. *Colonel Benjamin Tallmadge and Son William* by Ralph Earl, 1790. Mr. Tallmadge settled in the town of Litchfield, Connecticut, in 1784. He was a merchant and his green-striped ingrain carpet illustrates a popular type of British export. (Litchfield Historical Society)

176. Stenciled pattern simulating a woven carpet. The original floor, of which this is a copy, was found in a house in Cooperstown, New York (now the Cooper Inn), built 1813–1816. The gold background, with panel borders in blue and center designs in red, provided a colorful and thrifty substitute for expensive carpeting. (New York State Historical Association)

In rural districts, however, the situation was quite different from that in the cities. Various published reminiscences make abundantly clear that the majority of floors in country towns were left bare and were frequently sanded. "Scouring sand for floors" was even advertised in the *Boston News Letter* in 1746. Charles Carleton Coffin, recalling the small town of Boscawen, New Hampshire, in the early nineteenth century,

wrote: "Carpets, except here and there one of home manufacture, are unknown. The floors [of the front rooms are] strewn with clean white sand gathered from the shores of Great or Long Pond and swept into curved lines, scrolls, and whorls by a broom."[1] Other writers also remembered scouring with sand and water, the dry sand being later swept into pretty herringbone patterns.

Another type of floor decoration, more durable than sand, consisted of painting gay motifs on the wide pine boards. Although painting did not provide warmth in winter, or comfort for tired feet, it did enrich the aspect of the best rooms. Many clever simulations of woven carpet patterns, and others with geometric designs, were produced by traveling artists who also grained woodwork and stenciled plaster walls (fig. 176).

Domestic or locally produced floor coverings were the economical solution for country dwellers. Painted canvas, rush or rag matting, and hand-loomed striped carpets were all used until well into the nineteenth century.

Painted floorcloths first came to the Colonies as importations from England where they had been conceived as useful substitutes for high-priced woven carpets, decorative tile pavements, or wooden parquet floors. They were enthusiastically received in America, and many wealthy Massachusetts homes, such as those of Peter Faneuil, Joseph Barrell, and Elias Hasket Derby of Salem, used floorcloths in combination with Turkey and woven carpets in many of their major rooms. Made of heavy canvas (a combination of hemp, flax, or cotton), floorcloths were first treated with several coats of sizing, and were then stretched, decorated, and finally "seasoned" (thoroughly dried) to avoid the ever present danger of surface cracks.

Painted carpets were commercially manufactured and sold in eighteenth-century America and "carpet painting" was advertised in local newspapers. One could also purchase by mail from dealers such as T. Tenney in Exeter, New Hampshire, who would deliver special orders made up individually by size, color, and price. Patterns in great variety were available. Many were "stamped" or stenciled with geometric figures, others were done freehand with flowers or intricate borders, and

some were painted in imitation of Turkey or English carpet designs. If the surfaces became worn or soiled, they could be easily repainted with a minimum of trouble or expense. Two different floorcloths are visible in this 1793 portrait of John Phillips (fig. 177). Floor canvases were also made at home and numerous sets of directions have survived for the instruction of amateurs. *The Golden Cabinet* (Philadelphia, 1793), *A New System of Domestic Cookery* (Boston, 1807), and *The New Family Receipt Book* (New Haven, 1819) are among several early publications that offer entertaining reading. Even more interesting are the occasional descriptions of floorcloths written by the householder himself. One account, by Reverend Lyman Beecher, father of Henry Ward Beecher, recalls for his children life in East Hampton, Long Island, about 1800:

> We had no carpets, there was not a carpet from end to end of the town. All had sanded floors, some of them worn through. Your mother introduced the first carpet . . . She spun it, and had it woven; then she laid it down, sized it, and painted it in oils, with a border all around it, and bunches of roses and other flowers over the centre . . . The carpet was nailed down on the garret floor, and she used to go up there and paint.[2]

Today the use of straw matting is often connected with the late Victorian period and associated with golden oak woodwork and windows with small panes of colored glass. Actually, the use of straw carpets in America predates the Revolution. As early as 1749 straw mats began to appear in Boston inventories, and a "handsome Floor Straw Carpet" was offered at auction in the *Boston Gazette* of January 28, 1760. Even George Washington ordered matting from London for Mount Vernon in 1759, and orders were repeated by him in 1772 and 1789, when reference was made to "Floor matting from China."[3] It is obvious that most of the high-quality straw matting came into America through overseas trade. John Rundlett, a Portsmouth, New Hampshire, merchant, imported in 1809 straw carpeting from various foreign places, including Havana, Demerara, St. Vincent, and Trinidad, that sold for about 35¢ per yard.[4] A large cargo from China in the ship *Tartar* in 1816 must have

177. *John Phillips* by Joseph Steward, 1793. Mr. Phillips, founder of Phillips Exeter Academy, is believed to have been portrayed in his Exeter home seated on a painted canvas floorcloth. A second pattern appears in the adjacent room and a band of stenciling frames the window. (Courtesy of the Trustees of Dartmouth College)

supplied the needs of many New England homes, where straw matting was often substituted for woven carpets during the summer months. The *Tartar's* account book, owned by the Peabody Museum of Salem, Massachusetts, enumerates several varieties that include "Nankin Straw carpeting, Matts of figured carpeting, and matts of Canton Quality," all in varying widths and lengths to be made up in sizes as required[5] (fig. 178 illustrates straw matting in the Peter Cushing house, Hingham, Massachusetts). Floor coverings of natural fibers were not all imported, because many people in country towns made their own. In the reminiscences of Mary A. (Walkley) Beach, born 1824, she describes her home in the country town of Southington, Connecticut, as it appeared in her childhood:

> As far back as I can remember there were no carpets in the house. Very soon, however, mother herself cut flags in the marshy places and having colored linen yarn blue, red, yellow for warp, wove some homemade matting. This was for the best room which was the north front room, the place for company.[6]

Commercially made rag carpeting is still in use today, but because of the availability of remnants of fabric for the weft and linen or cotton threads for the warp, it was both easy and economical to produce on a handloom. As early as 1777 two "rag rugs" worth 8 shillings appear in the inventory of Colonel Archelaus Fuller of Middleton, Massachusetts. In 1808 a similar item was valued at $1.25. Few early references exist concerning the use or the making of old rag carpeting. Most of it was locally woven or made at home and finished in long strips to be sewn together to attain the desired size. One excellent description has been handed down in Edward Jarvis' *Traditions and Reminiscences of Concord* (Massachusetts, 1779–1878). Jarvis, who was born in Concord in 1803, writes:

> I remember that which was in my mother's parlor, in my boyhood. It was called a rag carpet—made of old woolen cloth, cut in very narrow strips, half an inch wide. These were sewn together and made into long strings, and woven as filling. The warp was of threads of flax or cotton or wool,

178. East chamber in the Peter Cushing house, Hingham, Massachusetts, by Ella Emery, c. 1878. The yellow and brown straw matting could have dated to the late-eighteenth-century period of the other furnishings that still remained in the room when painted one hundred years later.

. . . and this filling was of different colors . . . My mother made one within my recollection. She prepared the materials and sent them to Mrs. Nehemiah Hunt of Punkatasket Hill to be woven. This was a common kind of carpet, for most farmers and mechanic families . . . English carpets, woven in factories, came later; and were in families of the more wealthy and ambitious.

One of the most widely used rural floor coverings during the early nineteenth century was carpeting woven in narrow widths of one-half, three-quarters, and seven-eighths of a yard, with lengthwise stripes in several different colors as shown in figure 179. These carpets were easily woven on home looms as few had secondary patterns and thus required only interweaving of warp and weft threads. Usually made of cotton or of flax tow combined with wool, early examples were colored by the use

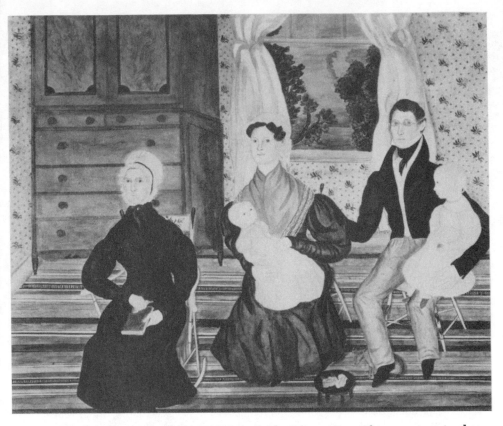

179. *The Talcott Family* by Deborah Goldsmith, c. 1825. This carpet, striped in various shades of green, yellow, and red, is typical of the home-woven products used in many rural families. Deborah was a young traveling artist who journeyed through small country towns in central New York State during the 1820s. (Abby Aldrich Rockefeller Folk Art Collection)

of domestic dyes. Often the yarn was spun at home and either locally woven or woven by itinerant weavers who traveled from town to town. Later factory-made carpeting displays a tighter, more even texture, and sometimes exhibits harsh shades due to the presence of chemical dyes. Pieces of old striped carpeting may still be found, their subtle gradations of colors, derived from natural substances that produced olive greens,

butternut browns, vibrant pinks, and many shades of blue, are a joy to the eye (plate 18). The types of yarn and quality of colors are determining factors in assessing the dates of home-woven or later commercially made examples.

Of course, if one did not have the means of acquiring a real striped carpet, an imitation could always be painted to "fool the eye." Mrs. Ruth Henshaw Bascom, the famous profile artist, did just that in her home in Fitzwilliam, New Hampshire, in 1830. On Tuesday, June 29, she recorded in her Journal: "I began to paint my parlor floor in imitation of a striped carpet. . . . 3 July Saturday . . . I finished painting my floor at 6 P.M. Striped with red, green, blue, yellow and purple—carpet like."[7]

Needlework carpets, because of their large size and perishable nature, were less widely used than some of their sturdier contemporaries. The best-known example is the Caswell carpet, owned by The Metropolitan Museum of Art, New York, and made by Zeruah Higley Guernsey Caswell in Castleton, Vermont, about 1835. A second carpet, measuring sixteen feet square, is embroidered in chain stitch with hunters, animals, birds, and floral designs. It was completed in 1844 by Mrs. E. G. Miner of Canton, St. Lawrence County, New York.[8]

The word *rug* to connote a small, scatter-size floor mat seems to have come into use in the nineteenth century when underfoot textiles such as hearthrugs began to augment room-size carpets. Early examples were produced at home and represent many hours of patient labor on the part of the housewife. They were spun, dyed, and crafted by hand, so materials and colors are indicative of date and provenance. Small embroidered rugs, the majority appearing to date within the first quarter of the nineteenth century, may be considered utilitarian offshoots of the decorative crewelwork of the eighteenth century. Many needlework rugs were floral in design. They comprised pots or baskets of stylized flowers and meandering vines, all exhibiting a definite affinity to ladies' art of the period. Some examples employed handwoven linen as the supporting fabric. When the rug was completed, the background was entirely concealed by the stitchery. Figure 180 is unlined and some surface portions

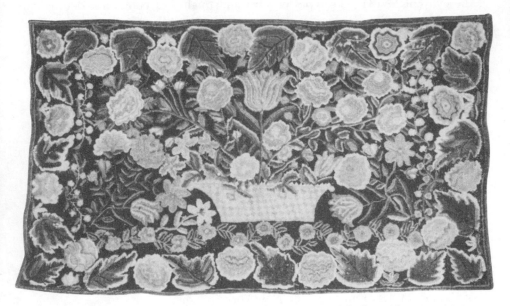

180. Needlework rug with basket design. Flower and leaf motifs are reminiscent of ladies' art of the first quarter of the nineteenth century. This rug employs woolen yarn on a handwoven linen background in muted shades of tan, rose, and green.

of the two-ply wool yarn show signs of wear, but it has apparently never been heavily used on the floor. The reverse is clean and unfaded and preserves the subtle shades of green, tan, and rose of natural dyes.

In another type of embroidered rug the patterns were outlined against visible backgrounds of heavy blanketing, coarse linen, or early factory-made woolen cloth, the last-named found in black, gray, or dark colors, the better to set off the needlework designs. Closely allied to these rugs are others ornamented with cutout homespun patches of various shapes, carefully stitched to a pieced, colored ground in the manner of an appliqué coverlet. Charles M. Hyde, telling of the early

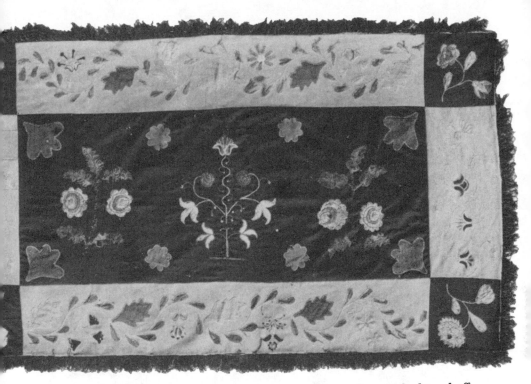

181. Appliqué and needlework rug, c. 1830. Fabric patches stitched to a buff-and-blue wool background are combined with embroidered designs to create an attractive but perishable floor covering.

days in Brimfield, Massachusetts, wrote: "The first carpets were introduced about 1802. They were made of square pieces of cloth sewed together, ornamented with various patterns cut from differently colored cloth, and sewed on. . . ."[9] Appliqué rugs sometimes combined fancy needlework with the applied designs. In figure 181 bright yarns are worked in buttonhole, satin, chain, and cross-stitch on a background of blue and buff wool fabric.

Yarn sewing was an early art in Colonial America, being particularly associated with the large coverlets or "bed ruggs" that span the one hundred years from 1720 to 1820. The foundations of these pieces were

182. Bed rug with the initials LM and dated 1821. Coverlets of this type appeared for more than one hundred years. Made of woolen yarn drawn to the surface in loops by a needle, they were the precursors of a few rare floor rugs made in the same technique.

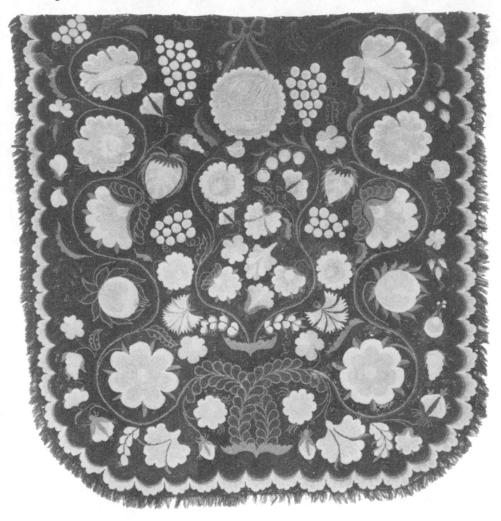

183. Yarn-sewn rug in mustard yellow, blue, and green with a linen support, early nineteenth century. One corner is turned back to show the short stitches visible on the reverse.

made of wool or linen, home-woven and worked in yarns colored with vegetable dyes. The method of sewing was a running stitch made with a large needle, probably of wood or bone. The yarn was carried for short distances beneath the foundation, reemerging on the surface in closely packed loops that were either left uncut or sheared to produce a thick soft pile. The bed rug illustrated in figure 182 is a handsome one, having a bold, asymmetrical design and the rounded corners and two-ply yarn fringe typical of many well-preserved examples. Found in New Hampshire, although perhaps not made there, it is initialed *LM* and dated *1821* on the circular cartouche suspended from a bowknot at the upper edge.

Yarn-sewn technique was also applied to floor mats, which were similar in many respects to the bed rugs, but most surviving examples do not appear to date before the early years of the nineteenth century. The homespun foundation and looped surface combined to make very soft, flexible rugs, and the beautiful shades originating in the home dye pot enhance the floral or rare geometric patterns (plate 19). Another

yarn-sewn rug, found in Maine, features a subtle combination of yellow-brown, dark green, and light blue (fig. 183). The background material is tow in which the shives (woody scales left from breaking the flax) still remain. One corner has been turned back to show the distinctive running yarn sewing. Long, narrow rugs of a perishable nature are often assumed to have been hearthrugs, because they served to protect more valuable carpets from burning cinders while not being subjected to heavy wear themselves. Occasional examples may be seen lying before fireplaces in paintings of the second quarter of the nineteenth century.

Yet another type of homemade rug may be recognized by its interesting shirred technique, sometimes termed *chenille* because of the soft appearance of the surface when the edges of the strips were raveled rather than folded. Although done with a needle, the procedure was

184. Shirred rug, second quarter of the nineteenth century. Small rolls of woolen fabric are sewn to the front of a heavy linen grain bag.

185. Detail of rug in figure 184. The individual rolls that make up the surface are attached with strong linen thread.

quite different from that used in yarn-sewn work. Narrow lengths of woolen fabric about one-half inch wide, sometimes cut on a bias, were most commonly used. After gathering to form puckered rolls, they were stitched onto the front of the foundation with heavy linen thread. Handwoven cloth, cotton sacking, and coarse linen grain bags are all seen in early specimens, the reverse showing only the long stitches used to attach the surface rolls. These rugs usually exhibit informal patterns

186. Rug shirred in patches, third quarter of the nineteenth century. The well-designed spray and deep yellow border combine to create a handsome visual effect.

that appear to be home-designed. Occasionally, however, a house or basket of flowers is reminiscent of young ladies' seminary art. The majority date from 1825 to the 1850s, although examination of fabrics and dyes constitutes the most reliable indication of period.

Figure 184 illustrates a homey example with shirred strips of woolen cloth stitched to a grain bag that still carries the initials of its owner. The fabrics are cleverly applied to depict a naïve design of house and trees, the oversize fruits being distantly reminiscent of eighteenth-century needlework patterns. A detail of the surface with its "caterpillar" rolls is shown in figure 185. Another shirred rug, perhaps dating to the mid-nineteenth century, appears in plate 20. The background is composed of folded strips tightly sewn and firmly pressed together. This method forms bands of dark, variegated colors through which cuts the pattern of bright, flowering vines. The heavy materials and firm technique result in a thick and durable floor covering. Quite the opposite

effect is attained in another shirred rug from the third quarter of the nineteenth century (fig. 186). In this case small circular patches with raveled edges were secured to the background at their centers, and appear on the surface as individual rosettes (fig. 187). The foundation in this case consists of remnants of printed dress fabrics reinforced with cotton padding. Woolen scraps of various kinds and dates were used to form the patches and the result is a loose textured rug. The deep yellow border encloses a flowering spray in shades of brilliant rose and clear green.

The ubiquitous hooked rug was the most widely used floor mat during the nineteenth century, retaining its popularity even to the present day. Its origin, dating, and design sources have been discussed many times in print, and no two authorities agree. But a consensus of opinion indicates that hooked rugs were made both in the United States and in Canada over a long period of time, and that few predate 1835. This technique did not use a needle as in shirred and yarn-sewn rugs; instead, short loops composed of narrow strips of fabric were drawn with a hook from back to front through a coarse foundation. Hooking may be recognized by continuous rows of flat fabric carried along on the underside. This method produced a solidly filled surface on the reverse—the pattern and colors corresponding with those on the face.

The majority of nineteenth-century hooked rugs were made at home but were composed of remnants of store-bought material colored with commercial dyes and hooked through burlap foundations. The use of burlap for this purpose establishes a post mid-nineteenth-century date because its component of jute (derived from the fibers of an East Indian tree) was not imported to America until about 1850. Occasional early examples may be found with linen foundations and sections of home-dyed wool yarn that supplemented the cotton loops and, when sheared, formed a soft rich pile.

Hooked rug patterns may be roughly classified as floral, geometric, and pictorial. Home-drawn designs tended to be less formal and less symmetrical than the repetitive stamped patterns that were offered through catalogues or sold from door to door. Figure 188 shows what

187. Detail of rug in figure 186. Circular patches of various woolen materials are loosely sewn to a backing of store-bought cotton dress fabric, resulting in an attractive but fragile rug.

appears to be an original composition of innate freedom and grace. The dark background that sets off the informal flower spray is composed of many odds and ends of cotton and woolen cloth. An obvious variety of fabrics and colors contribute their share to the charm of this naïvely crafted rug. Stags, lions, horses, and dogs were but a few of the creatures that appeared in multiproduced rug patterns during the last quarter of the nineteenth century. Posing stiffly amid stylized vegetation, or sur-

rounded by meticulously drawn borders, these animals were a far cry
from the endearing Vermont leopard who sprawls nonchalantly in the
center of figure 189. Homemade yarn fringe and a well-designed asym-
metrical surround combine to create a rug of unusual merit.

The name of Edward Sands Frost, born in Lyman, Maine, in 1843,
is prominently connected with the first process of stenciling hooked rug
patterns on burlap, which he then sold from his peddler's cart, begin-
ning in 1864. Between 1870 and his retirement six years later, he had cut
some seven hundred and fifty stencils and perfected his method for pro-
ducing the designs in color. Frost's original stencils are now in the col-
lections of Greenfield Village and Henry Ford Museum in Dearborn,

188. Hooked rug, last quarter of the nineteenth century. The burlap founda-
tion indicates a later date than is suggested by the home-drawn aspect of the
flower spray.

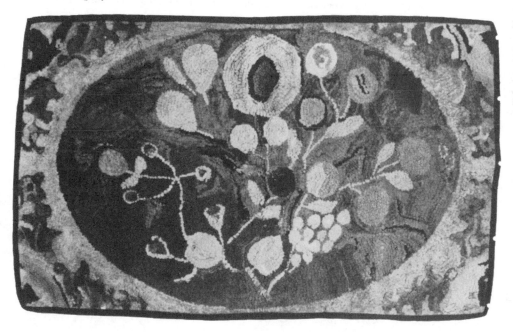

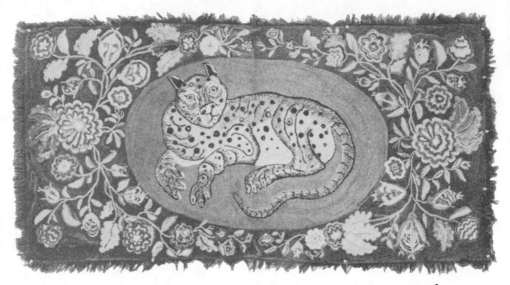

189. Hooked rug, leopard from Vermont, third quarter of the nineteenth century. Burlap with yarn fringe. The unconsciously humorous rendering of the animal is in striking contrast to the competent hooking of the subtly designed border.

Michigan, where his own patterns are again being reprinted for the use of present-day makers of hooked rugs.[10] Frost specialties included birds, beasts, florals, geometric, and fraternal motifs, but perhaps the most unusual group comprised designs copied or adapted from Oriental importations, which lost none of their richness when transferred to the home-hooked rug. The hooked rug in figure 190, circa 1870, rendered in many shades of rose and blue, presents an early example of Frost's pattern Number 108.

Following the Civil War the majority of handcrafts began to disappear, their form and function being perpetuated for commercial purposes by the ubiquitous machine. Mass-produced weathervanes were distributed through illustrated catalogues; stereoscopic views replaced the local townscapes formerly recorded by itinerant painters; fireplaces and their decorative fireboards were quickly outmoded by the parlor

stove; and cheap lithography displaced the brush of the lady amateur. By the opening years of the twentieth century old-time hooked-rug makers felt that homemade rugs were becoming things of the past. Grandmothers believed that the arts of crewel embroidery, weaving, and quiltmaking would be entirely unknown to their children's children. Ancestral homes were generally unappreciated, their inconveniences gladly exchanged for the easy-upkeep bungalows that heralded a new life-style characteristic of the upcoming generation.

Now, however, as the Bicentennial is upon us, we realize happily that none of these forebodings has come to pass, and that young people in particular, both for pleasure and for profit, are enthusiastically reviving the early country arts, which are now recognized as among America's proudest traditions.

190. Hooked rug from a stenciled pattern by Edward Sands Frost, c. 1870. This is a colorful copy of an Oriental Ghiordes rug.

NOTES

1. Charles Carleton Coffin, *History of Boscawen and Webster* (Concord, N.H.: 1878), p. 177.

2. Charles Beecher, ed., *Autobiography, Correspondence, Etc., of Lyman Beecher, D.D.* (New York: Harper & Brothers, 1864), vol. 1, p. 124.

3. Rodris Roth, *Floor Coverings in 18th-Century America,* United States National Museum Bulletin 250 (Washington, D.C.: Smithsonian Press, 1967), p. 27.

4. Ralph May, *Among Old Portsmouth Houses* (Boston: 1946).

5. Carl L. Crossman, *The China Trade* (Princeton, N.J.: The Pyne Press, 1972), p. 242.

6. David Nelson Beach, *Beach Family Reminiscences and Annals* (Meriden, Conn.: 1931).

7. Manuscript Journals of Mrs. Ruth Henshaw Bascom are in the Library of the American Antiquarian Society, Worcester, Massachusetts.

8. Homer Eaton Keyes, "A Note on Embroidered Carpets," *Antiques* (June 1926), pp. 298–402.

9. Charles M., Hyde, *Historical Celebration of the Town of Brimfield* (Springfield, Mass.: 1879).

10. *Edward Sands Frost's Hooked Rug Patterns* (Dearborn, Mich.: Greenfield Village and Henry Ford Museum, 1970).

Index